Rosemarie Trockel

A Cosmos

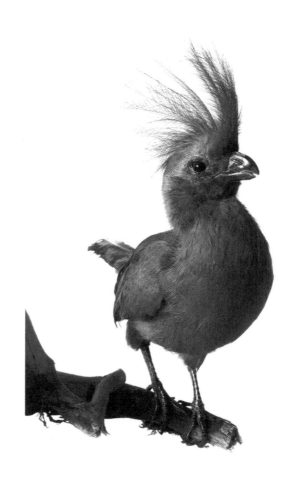

ROSEMARIE TROCKEL

Go Away Bird, 2011

Rosemarie Trockel

A Cosmos

With texts by:

Lynne Cooke
Dore Ashton
Suzanne Hudson
Anne M. Wagner

Museo Nacional Centro de Arte Reina Sofía

THE MONACELLI PRESS

Central themes in the exhibition *Rosemarie Trockel: A Cosmos* coincide with several strategic directions undertaken by the Museo Nacional Centro de Arte Reina Sofía, such as exploring the role of women in modern and contemporary art; redefining modernity through a re-reading of the lesser-known chapters of the avant-garde; and creating new cartographies that contribute to a more in-depth understanding of the complexity of art history.

The symbiosis between the discourses of the museum and the exhibition of this German artist is profound, and the significance of those concerns in the contemporary scene was demonstrated by the immediate interest expressed in this project by other art centers. Three world-class institutions joined the group: the New Museum in New York, London's Serpentine Gallery, and the Kunst- und Ausstellungshalle der Bundesrepublik Deutschland in Bonn. This new exhibition confirms the international profile of the Museo Reina Sofía and its prominent position on the global map of contemporary art museums and galleries.

The exhibition's title *A Cosmos* clearly states one of the artist's intentions: to offer us a way of ordering the world drawn from the personal imaginary—one's own universe of elective affinities. Trockel does not issue a dogmatic statement; on the contrary, she constructs a great stage wide open to debate. Her strategy is based on her dual role as artist and as gatherer of found objects and art works. The result of the painstaking labor of selection is a kind of "cabinet of wonders," recalling those that appeared across Europe during the era of discovery and with the explosion of modern scientific revolutions. These old collections of objects and images, though disparate and limited, imparted knowledge and offered an opportunity to glimpse the faraway and the unknown.

In her imaginary museum, the artist places her own production on an equal footing with other objects and art works. She thus establishes horizontal rather than hierarchical relationships, which reignite forgotten discourses and enrich her own production. Each visitor to the Museo Reina Sofía can uncover new meanings in this game of relationships that the project invites us to play. Our own critical capacity as viewers, and our active role in perceiving these connections, are both fundamental, as it is only by exercising them that the exhibition can be complete. On entering the museum galleries, and when turning the pages of this volume, an atlas unfolds before the viewer, displaying the work of renowned and outsider artists alongside watercolors, engravings, and glass models from the world of zoological and botanical research. They all have one thing in common: they are connected with projects frozen in time, ideas that were moving forward before they were stopped in their tracks.

Thanks to Trockel's exhibition, we can gaze at amazing illustrations by José Celestino Mutis and in Manuel Montalvo's notebooks; but we also rediscover Salvador Dalí, such an important figure in the discourse of the Museo Reina Sofía, and James Castle, a self-taught artist whose work has already been the subject of an exhibition here. With these works, the show suggests that art history, in dialogue with other disciplines, becomes an infinite spiral, a thrilling and plural journey, an experimental space. The project sets up an encounter between the outdated notion of the museum as a mere container of objects and the new idea of the museum as a laboratory of ideas, creating a productive dialogue between past and present. In this encounter, the search for the other and collaborative work are both fundamental concepts; they reflect an abandonment of artistic ego in favor of a broader kind of knowledge and aesthetic pleasure.

Rosemarie Trockel: A Cosmos crosses time and space to find Trockel's peers and uses their works to weave multilayered readings that are presented to the viewer as alternative paths. This exhibition shows that the sum of one plus one is an unknown quantity that exponentially multiplies the possible ways the world of art may illuminate our cosmos.

Ministry of Education, Culture, and Sport

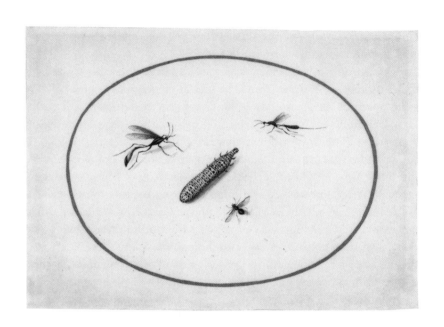

MARIA SIBYLLA MERIAN

*Caterpillar and Other Small Insects Made in Fine Miniature,
inside a Golden Ellipse,* before 1660

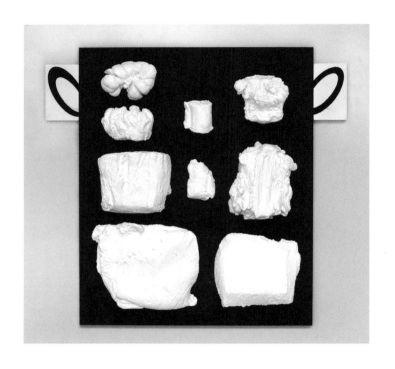

ROSEMARIE TROCKEL

Sprachwandel B, 2006

Foreword

The title of this exhibition recalls one of the earliest oppositions in Western thought, first articulated by the Greeks, that the world is *a cosmos*, not a chaos. Pre-Socratic thinkers used the word *kosmos* to signify "order"; however, its original meaning has passed into modern languages as "the set of all things that exist" or, in its most commonly understood sense, as the universe or outer space.

Not only is *A Cosmos* a title but a model, revealing much about Trockel's strategy as an artist while providing an insight into the purposes of museums and contemporary art institutions. This cosmos, with its indefinite article *A* (as opposed to *The*), unites two basic concepts: firstly, that there is an internal order to the ways in which humans approach and represent the world, and that this order can be questioned, and secondly, that this desire to map the world creates a series of interconnected constellations. The Trockel exhibition is not guided by scientific diagrams, hierarchies, or encyclopaedic labels, but rather by a set of objects borrowed from the fields of art history, botany, craft, and outsider art.

Another key consideration for the exhibition has been Trockel's pioneering role in the development of a feminist language and how this legacy might be captured in the selection of works. With a gesture that marked twentieth-century ideological and social history, feminist artists reconfigured themselves in relationship to the artwork, becoming subject rather than object. Paradoxically, as the figure of the author faded, a large group of women artists, including Trockel, sought to present different subjectivities in order to struggle against the powerful forces of the "death of the author" and male domination. At that time, feminism in art practice sought out the subversive potential of activities that had so often been relegated to women by an androcentric world, such as the textile-based crafts.

It is no coincidence that Agnès Varda, in her film *The Gleaners and I* (2000), made the connection between the archetype of the gatherer and those outsider artists working with found materials. Through selecting and combining different items, Trockel and the curator of the exhibition, Lynne Cooke, Deputy Director of the Museo Reina Sofía, expanded this notion by uncovering the disruptive nature of gathering, another task traditionally linked with femininity (which, it is to be noted, was a production model that in prehistory revolutionised human progress and evolution). This exhibition, a result of their gathering and gleaning, is created according to a logic that refers both to Surrealism's magnetic relationships and to the mysterious nature of individual desire. It results in a kind of living atlas that blurs the boundaries between disciplines and formats, presenting those discourses that may previously have been silenced or unseen.

"To see a film is to always compare it with others." This is one of the maxims that inspired Jean-Luc Godard's *Histoire(s) du cinéma* (1988–98), the immense film anthology that made a huge impression on several generations of artists and that continues to inspire an emphasis on stories rather than history. Comparison—not as a form of judgement but as the descriptive juxtaposition of elements—forms the basis of Trockel's current work. *A Cosmos* is not an exhibition with a narrow viewpoint, nor does it formulate a normal

historic narrative; its enormous communicative power rests in its engagement with those historical attempts to gain knowledge that arose from colonisation and the Enlightenment, which, among other things, produced the literary genre of "description." In this exhibition, the imperative to know and map the world reveals connections between, for example, collections of early botanical drawings and the notebooks of Manuel Montalvo, both offering an unusual instance of the intimate yet compulsive urge to search for order through descriptions.

A Cosmos returns us to a pre-cosmic moment; it orders but does not seek to build a definitive discourse. Trockel is fascinated by unfinished projects, by fractured scientific discourse, and by those artists whose careers have been suddenly cut short. Her genealogy of the imaginary feeds off logical thought, but she is less interested in the linear progress of evolution than in its offshoots, cul-de-sacs, and great diversity.

Rosemarie Trockel has long been admired for her highly independent and intrepid exploration of certain fundamental questions, and *A Cosmos* places her work in the company of others whom she regards as kindred spirits. In keeping with the nature of the exhibition itself, which invites reflection on collaboration and relationships, its travel to different venues is the outcome of the combined efforts of four institutions: the Museo Nacional Centro de Arte Reina Sofía, the New Museum, the Serpentine Gallery, and the Kunst- und Ausstellungshalle der Bundesrepublik Deutschland. Above all we thank the artist Rosemarie Trockel for her vision, enthusiasm, and commitment to *A Cosmos*, and for the unique opportunity she has given us to see these works together for the first time.

Manuel Borja-Villel
Director of the Museo Nacional Centro de Arte Reina Sofía

Lisa Phillips
Toby Devan Lewis Director of the New Museum

Julia Peyton-Jones
Director of the Serpentine Gallery and Co-Director, Exhibitions and Programmes

Hans Ulrich Obrist
Director of International Projects, Serpentine Gallery, and Co-Director, Exhibitions and Programmes

Robert Fleck
Director of the Kunst- und Ausstellungshalle der Bundesrepublik Deutschland

ROSEMARIE TROCKEL

Go Away Bird, 2011

JAMES CASTLE

all works untitled and undated

IMAGO MUNDI

Suzanne Hudson

A onetime clocksmith, silversmith, saddler, inventor, agricultural reformer, painter, and museologist, Charles Willson Peale was an archetypal Jeffersonian polymath.[1] In a stunning self-portrait completed five years before his death, *The Artist in His Museum*, 1822, Peale stands before his Philadelphia Wunderkammer—the first natural history museum in the United States—theatrically raising a damask curtain to expose the world he had built within: portraits of heroes from the Revolutionary War, shadowboxes, ornithological displays, and a fully reconstructed mastodon that he had excavated from the Hudson River Valley in 1801 to national acclaim (see p. 15). To render the pictorial structure homologous with its subject's classificatory premise, the illusionism of the foreground gives way to a deeper perspectival system within which the vitrines and members of the public are pinioned. Equal parts supplicant and carnival barker, Peale hovers at the proscenium, beckoning beholders into the interior recesses. Even in the front there is much to see, most obviously the palette and brushes turned up to the edge of the picture plane and the exquisitely rendered bones laid at Peale's feet.

An early adopter of Linnaean taxonomy, Peale's curatorial project is exactingly composed; samples procured by him and others (specimens from the Lewis and Clark transcontinental expedition to the Pacific of 1804-6 are especially notable) manifest an engagement with the physical world that is fundamentally aesthetic. But no less was it didactic, since Peale drafted labels translated into three languages to ensure the viability of self-directed learning. Yet in spite of the pedagogical aspirations Peale maintained for his collection, portions of it would eventually be sold off to the impresario P. T. Barnum, following Peale's own commercialization of his exploits and quixotic use of his exhibits. Tellingly, his great exhumed and reconstructed mastodon skeleton—simultaneously an anointed symbol of continental prehistory and a promissory note to the scientific evolution of the new American republic—rather too easily became hyperbolic décor, serving as an elaborate canopy for the dinner parties held under its commodious frame.

Given these acts of promotion—with which the self-portrait must be tallied—it is unsurprising that Peale's museum would have attracted any number of notable guests, and for a variety of reasons. In 1804, German explorer and naturalist Alexander von Humboldt

(1) See Charles Coleman Sellers, *Mr. Peale's Museum: Charles Willson Peale and the First Popular Museum of Natural Science and Art* (New York: Norton, 1980); and David C. Ward, *Charles Willson Peale: Art and Selfhood in the Early Republic* (Berkeley: University of California Press, 2004).

visited, fresh on the heels of the South American voyages (made with Aimé Bonpland and Carlos Montúfar) that would confirm his own renown. Before he returned to Europe, and following a trip to Washington where Humboldt met with the President at the unfinished White House, he sat for a portrait by Peale, for the museum.[2] The intimate terms of the sitting remain unknown, but one imagines a kinship between these men, a shared sympathy. The "curiosities" shown in Peale's Wunderkammer confirm the extensibility of knowledge as predicated on the expedition-based inquiry, epitomized by Humboldt, which had sourced them. And while Peale personifies a specifically American embodiment of such drives, both men would bequeath as this period's legacy a universalizing impulse toward conquest through knowledge, categorization, and ratiocination. That same drive yielded Humboldt's *Kosmos*, a monumental, multi-volume treatise (published between 1845 and 1862, with the last installment appearing after his death in 1859), in which he attempted to "represent in one work the entire material universe, everything we know today of the phenomena in the celestial spaces and of life on earth, from the stars in the nebulae to the geography of mosses on granitic rocks."[3]

If the extinct mastodon suggested for Peale and his fellow countrymen an easy allegiance between excavation and patriotism that assumed the success of future territorial expansion (i.e., other fantastic dimensions of the wilderness could be subjugated), it also provided knowledge of a past accessed by—even evidenced through—the geophysical. This equation between people and place or, in the terms just articulated, history and geography, held for Humboldt, too. Across some 6,000 miles detailed in his writings, we learn, for example, of Aztec art in addition to the catalogued flora and fauna likewise indigenous to the regions he visited. Citing the influence of Humboldt's *Kosmos*, Thomas DaCosta Kaufmann argues that "the disciplines of art history and geography developed in parallel"[4] in Germany in the nineteenth century, with expansion of university positions in those disciplines and with publications about art that were broad in their geographical purview and, conversely, writing about geography that addressed its relation to human culture.

Taking up this critical legacy, Rosemarie Trockel returns us to a kind of *Kunstgeographie* shaped by Humboldt's ideas. Her work, together with objects and artworks by others that she has chosen, becomes an "art/geography" (indicated in the title, *Rosemarie Trockel: A Cosmos*, which recalls Humboldt's grandly ambitious book). The artworks often are relatively unknown and sometimes, as with those by James Castle, made outside and with no awareness of institutionalized contemporary production, while the artifacts have been detached from their past lives as scientific studies. Appropriated thusly, the entomological watercolors of the metamorphic life cycles of moths and butterflies painted by Maria Sibylla Merian or the gorgeous results of botanist José Celestino Mutis's fieldwork (long lost in the Spanish archive to which he delivered them from the New World) bespeak an obligatory breadth of knowledge as complement to the technical facility required to render them. Far from being recontextualized so that the original function is obliterated—an up-

(2) See Laura Dassow Walls, *The Passage to Cosmos: Alexander von Humboldt and the Shaping of America* (Chicago and London: The University of Chicago Press, 2009).

(3) See Humboldt's 1834 letter to Karl Varnhagen, quoted in L. Kellner, *Alexander von Humboldt* (London and New York: Oxford University Press, 1963), pp. 200-202.

(4) Thomas DaCosta Kaufmann, *Toward a Geography of Art* (Chicago and London: The University of Chicago Press, 2004), p. 43.

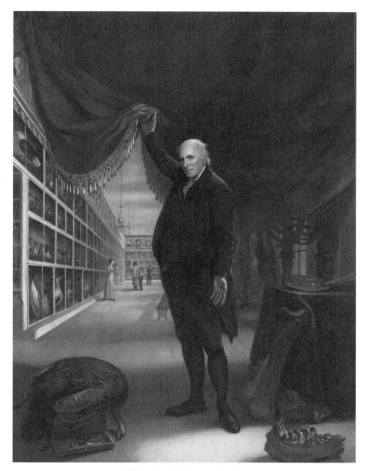

Charles Willson Peale
The Artist in His Museum, 1822
Oil on canvas, 263.5 x 202.9 cm
Pennsylvania Academy of the Fine Arts, Philadelphia
Gift of Mrs. Sarah Harrison

shot of the Duchampian contract of aesthetic nominalism and the museums that sustain it—these recordings of insects and plants persist as aids to classification even as they admit the necessity of aesthetic means for the success of this function.

In the case of Leopold Blaschka and his son Rudolph, realism is upheld as a first principle to parallel ends. Descendants of a family of artisans, the men made life-size, anatomically accurate glass models of plant species and aspects of enlarged flower parts in their Dresden workshop. The fine detail they achieved through a process that entailed the use of clear and colored glass (supported by wire armatures and sometimes painted on the surface) surpassed extant papier-maché or wax counterparts and thus was better suited for teaching botany. That the Blaschkas spent decades in the service of Harvard University, crafting upwards of three thousand items to be studied—and that these virtuosic pieces ended up in the Harvard Museum of Natural History and not in its galleries devoted to art—seems to matter a great deal. Their eventual obsolescence in the face of emerging technologies of preservation underscores the memorializing cast of the genre, the trajectory of which comes

close to the thematics of still life as traditionally conceived, for instance, intimating vulnerability through iconography (e.g., ripe fruit anticipating consumption or buds in full bloom awaiting detumescence).

Despite Trockel's emphasis on items such as these, whose slippage from use-value causes us implicitly if no less forcibly to reconsider the criteria by which these assignations get made, she also regards such works as excessive; indeed, the Blaschkas' project is as compulsive as they come. Theirs is a formal practice that cannot but admit its own eccentricities and that portends its own unsustainability (apart from the eventual archaism of the technique, the Blaschkas never trained an apprentice, meaning that the pursuit died with them). In this, it resonates with the aforementioned work of James Castle. Born two months prematurely and absolutely deaf, Castle grew up in rural Idaho on the farm of his parents, who served as postmasters and managed a small general store from which Castle pilfered mail-order supplies and seized anything flat for use as support for his pictures. Self-trained, Castle intuitively fabricated tools: he mixed soot collected from a wood-burning stove with saliva to make pigment for rendering, which he accomplished with wadded cotton and cloth, sticks, and nails that he expediently outfitted for the task of depicting his quotidian experience, from the minute decoration of bedroom wallpaper to the dense texture of place.

Castle never took up an occupation other than making art, and despite his labeling as an "outsider," much of his work reflects on its status as pictures and incorporates such motifs as frames so as to better announce the fields they contain as representational. Like the Blaschkas', his is an act of abundance; he hoarded ephemera, out of which he made art every day, and lots of it. Then, caring for it, he packed it in bundles for safekeeping. Unlike theirs, though, his realism is everywhere undercut by moments of subjectivity and willful mediation. One senses the artist's presence in the room he is drawing, but one also is aware of what he forgoes (seasons, for example, either are absent from his outdoor scenes, or it is perpetually spring) or what he abets (repetitions derived from a certain postcard of a car driving through a redwood tree recur in the unlikeliest of compositions).

Judith Scott, like Castle, worked independently and at a profound remove from her peers. A deaf-mute born with Down syndrome, her hearing impairment went undiagnosed during her childhood in Ohio, leading to a further verdict of her being uneducable. Scott was eventually placed into an institutionalized care situation from which she was only released some three decades later when her twin sister moved her to California in 1985. It was in Oakland that Scott began frequenting the Creative Growth Art Center where she was exposed to fiber art and where she applied herself to fashioning the sculptures for which she is known: anthropomorphic figures, typically in vivid colors, composed of armatures of bamboo or some admixture of found materials, wrapped, bundled, or bandaged with knotted cloth or yarn. Frequently evocative of cocoons, and invariably related to the body of the artist who made them, these aggregations raise questions of intentionality and process, even as they convey a physical intelligence shaped by experiences for which the works might be compensatory (or even apotropaic).

Scott, like *A Cosmos*'s other paragons of dedication and self-direction, achieved in a state of isolation a creative becoming. Without reinscribing the clichéd parity between artist and explorer—both ostensibly pursuing the unknown, whether in the recesses of the un-

conscious or at the outer edges of the map—it is worth noting the very practical insistence upon the primacy of epistemological questions yielded by both modes of doing. (The cartographic tradition of labeling parts "unknown," and populating said nether regions with fantastic beasts, very literally admits the limits of enlightenment, subject though they inevitably are to being redrawn.) For theories of knowledge are at stake in *A Cosmos*, not least of which are those relating to understanding Trockel's art. How we come to know it importantly happens in dialogue with Trockel's staging of self-reflexivity, and allowance for the instantiation of our own through her strategies of installation.

An operation central to *A Cosmos*, this staging of self-reflexivity has nonetheless structured her work (where she returns to themes—the sea, Brigitte Bardot, the animal kingdom—over many years) and its display alike. As Jörg Heiser puts it: "When established artists express doubts about the 'format' of the retrospective being appropriate to the multi-faceted nature of their oeuvre, it can come across as somewhat precious. . . . [S]uch doubt is central to [Trockel's] artistic approach. From year to year her approach is a fertile reassessment, at times a negation and at other times an unexpected reaffirmation, of her earlier work."[5] To wit: Trockel showed video for the first time in 1991, and then only to serve "as additional information aimed towards a better understanding of the rest of her work."[6] Elsewhere, and more recently, we find references to her retrieving abandoned efforts, recuperating them, and reframing their significance.

"In two major exhibitions mounted in 2002 (roughly twenty years after her first solo exhibition at the Galerie Monika Sprüth in Cologne) and in 2005, Trockel reconsidered how different aspects of her practice inform one another," writes Gregory Williams. What interests him specially is the way Trockel comes to designate her paper projects as works in progress. They first appeared at the Dia Center for the Arts in New York, under the rubric "maquettes for unrealized books and catalogues, 1983-2000," and later, at the Museum Ludwig in Cologne, as *Buchentwürfe* (drafts for books); in the semantic shift from "unrealized" to "drafts," Williams locates "an evolving process of self assessment,"[7] which can be extended to her meditations on authorship more generally. Comparably, Lynne Cooke titles an essay "In Medias Res,"[8] setting up a discussion of Trockel's output as productive of lateral thinking—often regarded in the universe of Trockel discourse as rhizomatic, following the seminal formulation of Gilles Deleuze and Félix Guattari—in relation to which we find ourselves forever engaging associative chains engendered but not delimited by what the artist sets before us.

Eschewing a linear retrospective in the present context, Trockel effects a platform for juxtaposition and allusion. Her important exhibition *Rosemarie Trockel: Bodies of Work, 1986-1998* was seen in a similar manner ("the exhibition itself is a work by Rosemarie Trockel"[9]). Still,

(5) Jörg Heiser, *Frieze* (September 2005), now online at: http://www.frieze.com/issue/article/the_seeming_and_the_meaning/ (accessed June 2012).

(6) Yilmaz Dziewior, "Pattern-Book World," *Rosemarie Trockel: Bodies of Work, 1986-1998* (Cologne: Oktagon Verlag, 1998), p. 78.

(7) Gregory Williams, "The Art of Indecision: Rosemarie Trockel's Book Drafts," *Rosemarie Trockel: Drawings, Collages,*

and Book Drafts, eds. Anita Haldemann and Christoph Schreier (Basel: Hatje Cantz, 2010), p. 9.

(8) Lynne Cooke, "In Medias Res," *Rosemarie Trockel,* Ingvild Goetz, Rainald Schumacher, eds. (Munich: Sammlung Goetz, 2002).

(9) Uwe M. Schneede et al., "Foreword," *Rosemarie Trockel: Bodies of Work, 1986-1998* (Cologne: Oktagon Verlag, 1998), p. 7.

where *Bodies of Work* was structured around various so-called chapters that reflected abiding media and themes of her corpus, *A Cosmos* pushes outward, further complicating the summary-resistant heterogeneity of her drawings, collages, knitted paintings, ceramics, videos, furniture, clothing, and books. As an act of curatorial engagement, *A Cosmos* is a "work," in the above sense. Akin to *The Artist in His Museum*, *A Cosmos* constitutes a spatialized self-portrait of the artist in a museum of her making; contrary to it, *A Cosmos* willfully decenters a Trockel who might prove transparent to subjectivity, much less to meanings or a truth expressed therein. For the show's opposition to the iconic complements a disavowal of the claims to consolidation of mastery and genius so crucial to Peale's enterprise (and which, to be sure, remain familiar from episodes of advanced modernist art in the past century).

This distantiation serves another sort of utility. A signal function of the Wunderkammer was its allowance for the application of mnemonics: *imago mundi* as theater of memory. Frances Yates describes forms of artificial remembering that fix passages to be recalled through visualizations of locations (Shakespeare's Globe Theatre remains exemplary); these so-called memory palaces helped the user retain vast swathes of knowledge in an easily retrievable fashion. "We have to think," she writes, "of the ancient orator as moving in imagination through his memory building *whilst* he is making a speech, drawing from the memorized places the images he has placed on them."[10] One's fluency with the imagined space was primary for the act of artificial memory to work, which is why the ordered rooms often corresponded to the layout of a building or a collection. As Yates notes, summarizing a classical source:

> The formation of the *loci* [the places on which to imprint memory] is of the greatest importance, for the same set of *loci* can be used again and again for remembering different material. The images which we have placed on them for remembering one set of things fade and are effaced when we make no further use of them. But the loci remain in the memory and can be used again by placing another set of images for another set of material. The loci are like the wax tablets which remain when what is written on them has been effaced and are ready to be written on again.[11]

These locales were so ingrained in the memories of their users that the entire edifice of a memory palace could, as it were, be recycled with different particulars while retaining its integrity as an organizing form.

The method Yates describes is helpful in theorizing what *A Cosmos* proposes as a model of thought advanced through arrangement—for Trockel first, and for us. Not an empirical effort at redoubling the phallocentrism of the encyclopaedists, this model admits that the uses of objects—made and found—exceed the expectations of their creators. Although this elevation of individualized experience, as radicalized by Trockel's choices of co-exhibitors and her redrawing of a canon through their inclusion, could well be understood relative to the sign of gender that sometimes unifies her morphologically dissimilar art, it also speaks to her deeply humanist inquiries into the nature of bodies and thinking, and how

(10) Frances A. Yates, *The Art of Memory* (Chicago: The University of Chicago Press, [1966] 1974), p. 3.

(11) Ibid, 7.

we come to know the latter while stationed in the former. Here, finally, the Wunderkammer as performed by *A Cosmos* comes cannily close to a decisively contemporary predicament in which the sorting of retrieved information based on personal proclivities situates one simultaneously as consumer and producer—as so many agents involved in commensurable projects of knowledge.

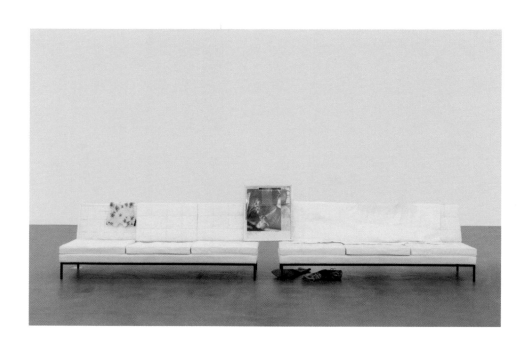

ROSEMARIE TROCKEL

Copy Me, 2010
Acrystal, steel, textile, wool, leather, and mixed mediums
Approx. 101 x 444 x 70 cm
Private collection

TROCKEL'S WONDERLAND

Anne M. Wagner

Do kids today still read about Alice, I wonder, and tumble with her down down down the rabbit hole until at last they touch bottom and come across the little bottle and even smaller cake? "DRINK ME," reads the label on the bottle. "EAT ME," commands the currant-studded cake. And so begins a round of bodily changes, a shrinking and growing that even clever little Alice is helpless to control—inevitably, in a "nonsense" narrative that so obviously concerns (among other things) the bewildering transformations involved in growing up.[1] In Lewis Carroll's story, life's metamorphoses are confusing to all but the Caterpillar; perhaps his attitude is an effect of the hookah, but *he* isn't bothered, "not a bit."[2] Or is it simply that in the cyclical cosmos of the caterpillar, even the most splendidly transformative changes are utterly routine?

I do not know if Rosemarie Trockel is a reader of Carroll. Yet I am struck by how much their imaginations seem to overlap. Like Carroll, Trockel is drawn to what seems oddly "unnatural" in human constructions of nature and the cosmos. And if Oxford University's Museum of Natural History is still home to some of the storyteller's favorite specimens (the dodo and flamingo among them), the Reina Sofía exhibition will see a staggering sample of images and objects to which Trockel feels an affinity, from Maria Sibylla Merian's observations of lepidopteran life cycles to James Castle's poignantly homemade birds.

If writers could be included in this wondrous assembly, I nominate Carroll to take a place among them. And why not? Like him, Trockel has studied nature's representations and specimens in a whole range of versions and forms. Like him, she brings animals and humans together, in situations where the differences between them begin to fray.[3] Like him, she makes utterly intentional use of the powers of nonsense. And there is more: The world of her work, like his Wonderland, initiates its audience into a sphere whose rules and denizens are usually not quite as expected. And as for familiar words and ordinary objects, both of these categories also go distinctly awry.[4]

(1) In the final chapter, "The Child as Swain," of *Some Versions of Pastoral*, William Empson provides a brilliant overview of the possibilities of psychoanalytic and Darwinian interpretation of Alice's tribulations and acquaintances in Wonderland. William Empson, *Some Versions of Pastoral: A Study of the Pastoral Form in Literature* (London: Penguin Books, [1935] 1966), pp. 205-33.

(2) Lewis Carroll [Charles Dodgson], *Alice's Adventures in Wonderland*, Chapter V.

(3) Of Trockel's long-term interest in animals, Gregory Williams writes: "Animals have long provided Trockel with source material for fantasies and projections: they have been all-purpose vehicles for the exploration of otherness." See "Split Nature: Laughter and Malice in Rosemarie Trockel's Houses for Animals," *Rosemarie Trockel: Post Menopause* (Cologne: Museum Ludwig: n.d.), p. 56.

(4) Among these specimens should be included the dodo, flamingo, duck, lory, eaglet, and rabbit.

Consider the commands issued by that little cake and bottle. Trockel's viewers are likewise given an urgent instruction by an apparently ordinary object: *Copy Me*, insists the title assigned to a 2010 sculpture of a couch (see p. 20). A couch is an unusual, as well as an unusually obscure, subject for sculpture: if we are always well advised to give Trockel's titles close attention, *Copy Me* sends us down yet another rabbit hole, this one deep enough, interpretively speaking, that the unwary victim can only hope that obeying its cryptic order will help dig her out.[5] But how? Can it really be addressed to us? How are we to copy a couch? We could draw it, perhaps, or act out a parody of "couchness." Both options seem lame, for the simple reason that the copying commanded by the title has already occurred, not once, but twice. As a sculpture, *Copy Me*—so its imperative label and hiccuping format firmly insist—is all about reproduction and redundancy: the work is no more (no less?) than two matte ceramic couches, each an exacting replica of a much-used specimen of modernist furniture originally manufactured (this is clear from its astonishingly rendered texture) in leather and steel.

"Much used" in the literal sense: the couch reproduced in *Copy Me* displays the wear-and-tear of years of service. Surfaces are scuffed, seams are splitting, the leather has started cracking, and worse still, a cushion is missing from the back.[6] And, just to be clear, the repetitive format of the sculpture makes all these small disasters happen twice. A single couch served as the basis for a mold, and was then twice remade in matte ceramic. The results are lined up side by side, the whole length covered in a single sheet of translucent plastic, as if to ward off dust. This shrouding only occurred, however, after the addition of two colorful articles of women's clothing, a blouse and a pair of moccasins, one at each end.

What is to be made of these untidy insertions? I think of them as props, or perhaps even spoor—surely they have the impact of bodily traces, signs left behind. But how should the signs be read? Might they be meant as blithe, even disrespectful, violations? Or are they meant as ironic, updated instances of the proverbial "woman's touch"?[7] Or do they bring an implication of a casual dressing (or undressing) that adds unexpected eroticism to the starkness of the couch? Whatever our reading of their role in the work's staging—and *Copy Me*, along with its even more pointedly titled sibling couch sculpture, *Replace Me,* 2011, certainly comes across as one of Trockel's most theatrical works—their presence is only a contributing element to a larger rhetorical purpose, and a further piece of evidence, if more is needed, that with this work, Trockel is willfully breaking the rules.

Consider the full extent of its aesthetic trespass: here is a reproduction of a paradigmatically tasteful modernist object, which in its sub-Miesian elegance could easily serve as the centerpiece in any up-to-date interior, public or private, from about 1930 on. Yet while a single ceramic version of such a signature object could easily read as a tour-de-force tribute to a powerful cultural moment, putting two down-at-heel pottery couches together cannot

(5) For a study of the significance of Eva Hesse's titles, see my essay, "How Eva Hesse Named Her Work," *A House Divided: American Art since 1955* (Berkeley and Los Angeles: University of California Press, 2012), pp. 185–201.

(6) The webbing of the sofa's substructure is thereby brought into view. Note, however, that these underpinnings are not to be confused with the *sculpture's* actual underpinnings, which kept its clay body from slumping in the kiln.

(7) While there is a limit to the extent that a text such as the present essay can burden itself with exhaustive description, it does need noting that whether or not the articles of clothing Trockel included were randomly chosen, they are still charged with the specificity of time and place. The blouse is made of an expanding polyester fabric that was a mass-market trickle-down from Issey Miyake pleats; the brightly colored and patterned moccasins derive from Native American patterns.

help but erode the power of the trophy design. *Copy Me*: This is an occasion when imitation goes beyond flattery to become its opposite. Both an era and an ethic have been put under wraps. In so enthusiastically carrying out the instruction of its title, the work ends up insisting that the principles governing this exemplary object are so much worn-out furniture.

If Trockel's work of the last three decades offers a retort to the modernist aesthetic, it has also suggested much more. Its embrace of the time-tested practice of copying has allowed her to investigate the larger sphere of representation's rules. Her art feeds on puns and doubles; the making of "good" and "bad" copies is its meat and drink. In other words, Trockel's copies are a nonconformist means of disobediently refiguring the familiar norms of the object world—art objects included. Paint becomes yarn, spirited handling is replaced by standardized patterns, animals become the subject of portraits, sculpture is apparently produced in the most casual or, conversely, most automatic of ways.

Such departures—such infractions—declare that the havoc her art has wreaked is addressed to convention, expectation, and precedent as they delimit the practice of art. Trockel is devoted to strategic transformation and radical refashioning, and the uncanniness of the cosmos constituted by and in her art is shaped by these topsy-turvy goals. In those reversals, we cannot help but see connections to Carroll, whose commitment to nonsense and satire—or nonsense as satire—saw him inventing talking playing cards, to say nothing of a stressed-out rabbit wearing gloves and waistcoat, the above-mentioned flamingo doing duty as a croquet mallet, and an ugly baby morphing into a cute little pig. These creatures, like Trockel's objects, are also quasi-copies, avatars of "civilized" society, the people and customs Alice has left behind.

Where Trockel and Carroll inevitably part company, I think, is in the particulars that shape their respective Wonderlands, the strange worlds beyond the looking glass, the worlds we are asked to grasp. Trockel's most recent works, *Copy Me* among them, seem to have been elected—and perhaps even produced—to serve as guides to the refractory universe imagined by her work. They have fuelled the sense, in this viewer at least, that within her aesthetic territory, the polemical temperature is heating up. Imagine global warming in the world of one artist's work.

How can we tell? As gauges of that intensified atmosphere, Trockel's newer works deploy both word and image in clearly declarative, even programmatic ways. In other words, they declare, if not what they are about, then at least that this is a question the viewer would be well advised to ask. They open an interrogation of her increasing engagement with metamorphosis and the natural, with this matter of "good" copies and "bad" ones. Can exemplary works indeed bring such issues into view? The process is, as the artist herself has declared, "not straightforward, not so clear." The context, interestingly, is an often-cited passage in which Trockel points out just how complex such communications can be: "The fact of being a model doesn't indicate whether it's a positive model, whether it's good or bad. A model is not straightforward, not so clear: it's made out of circumstances, including your own perspective. There is no model for how to deal with a model."[8]

(8) Rosemarie Trockel, as cited by Lynne Cooke in "Rosemarie Trockel: *Spleen*," an introduction to an exhibition of that title curated by Cooke and presented by the Dia Art Foundation, October 16, 2002–January 11, 2004. See http://www.diacenter.org/exhibitions/introduction/25 (accessed April 2012). The citation was originally extracted from Lynne Cooke, "In Medias Res," *Rosemarie Trockel* (Munich: Sammlung Goetz, 2002), p. 23.

One reason this last phrase seems so useful when thinking about Trockel's art is the stress it puts on prizing open the interpretive field to its widest extent. "There is no model for how to deal with a model": when the artist speaks of models in this statement, she seems to have two purposes in mind. The first is to suspend the unchallenged status of familiar approaches to (and explanations of) exemplary objects and works. No case is open and shut; each needs considering anew. The second is to address the idea of the model in terms that put aside age-old assumptions about artistic copying: artists (as opposed to naturalists, for example) have uniformly been understood to refigure those aspects of art and nature that they see as exemplary, inspiring. Simply amassing information is not the goal. For surely it would be wrong to repress one's own originality for the sake of an unworthy model? One way or another, the artist's chosen object (Dürer's hare, for example, or the Belvedere Torso, or the Sistine *ignudi*) must have valuable lessons to convey. Or so we customarily assume. Except for the works of Trockel, that is. There knowledge operates differently, circumstantially; it is never cut and dried. Where value is at issue, she steers clear of *idées reçues*.

In the light of this insistence on the complexity of models, consider a new wood and ceramic wall piece that the artist titled *Sprachwandel B* (2006). A construction that loosely takes the form of a tablet or palette, it is a work that explicitly returns to the problem of the model, presenting it as both a matter of imagery and a question of process, of sculptural technique.[9] And perhaps of language, too: the work's title, loosely translated, might best be rendered in English as *A Change in Language*. More vivid, perhaps, is its French translation, *Changement de langue*, which necessarily, unavoidably, invokes the tongue.[10] The vivid physicality of the phrase cannot help but point to the bodily organ that plays a starring role in *Sprachwandel B*. One of eight meticulously detailed ceramic casts, its carnal shape stands out. Unlike the other seven shapes affixed to the work's solid black surface—shapes that though clearly cast from "life" are oddly mute about their origins—the eighth is disturbingly legible. An animal organ cut away from its parent body, its visceral "language" inserts real life—and death—into the all-too-familiar life cast. About its creaturely origins there can be no mistake.

Is this the change of which *Sprachwandel B* speaks? From taxonomic vagueness to diagnostic certainty? Or does its energy move in the opposite direction, from a once-functioning organ to vaguely meaty slabs and morsels of unsourced stuff? Meaty, but also mute: all these ceramic shapes have a closely-grained matte surface that seems to seal each object off. The result seems less about speech than silence, with *Sprachwandel B* leaving the viewer stranded somewhere in a communicative process with neither beginning nor end. Where did its self-declared changes begin? What came first? The back-and-forth between *Sprachwandel B*'s two languages rephrases the unanswerable chicken-and-egg conundrum in terms of a physical and formal face-off. Neither side can win.

(9) Looking at this work, one might think for example of Adolph Gottlieb's 1944 painting *A Palette of Imagery*, which exemplifies his characteristic use of the grid.

(10) This work, which was exhibited publicly in an exhibition curated by Dirk Snauwaert, at Wiels, Brussels, as part of *Rosemarie Trockel: Flagrant Delight*, February 18–May 27, 2012, was identified there by its German title; French and Flemish translations were provided for the benefit of the local audience. Interestingly, however, though Trockel's first language is German, she will sometimes title her works in English, a decision that lends further weight to the view that her linguistic choices demand careful scrutiny.

No one can mistake the strange urgency of Trockel's recent imagery. Half playful, half macabre in its forms and its formlessness, it savors its own beauty, while taking aim at ideas of beauty in the work (or world) of art. If we were to use the artist's own language, the goal could be named as "abuse." Or so we are led to conclude by another Trockel title, *Abuse of Beauty*, which she deployed in 2009. The phrase named one in the large group of ceramic table pieces produced at apparently regular intervals over the last three or four years. Not all of them have been titled, but the descriptive labels that have been used seem to take aesthetic havoc as their rule of thumb. Her works do the same.

What is needed to make beauty suffer? Trockel's answer offers a backhanded beauty of its own. It takes the form of a glistening glazed green formlessness, created when sandy clay is piled high in grainy globs and lumps. Or when, in a ceramic table piece entitled *In einer Nacht von Schwarz zu Weiss (From Black to White in a Single Night)*, 2007, clay is amassed to resemble a great rock of pitted lava, an abused form of beauty arrives in the guise of a deliciously thick and creamy white glaze that flows among the crags. Cream, or even cum: in all these works, beauty is punished at the hands of abjection[11]; Trockel's ceramics revel in their terrestrial origins as never before. If clay is an eminently tactile medium, both its literal origins in (or as) earth and its metaphorical equation with the body means that an every-ready scatology is hard to keep at bay.[12] And Trockel does not always try. One need not dwell for long on *Thank God for Toilet Paper*, 2008, to see that this work makes profligate use of the long clay sausages inevitably deployed to model what, in a quite different context, Freud so memorably termed the fecal stick.

Perhaps it is only when linking Trockel's most recent sculptures to her earlier works that one begins to grasp how much sense can be made of this apparently diverse set of objects by understanding them as *versions* of sculpture—representatives, perhaps even paradigms of a genre, not merely discrete sculptural creations in and of themselves. Each is itself exemplary, in other words. Take *Less Sauvages than Others No. 2*, a pointedly minimal plaster from 1989. Its title alone suggests it ought to stand out somehow—it is "less sauvages," at any rate. The phrase calls attention to the minimalism, whether real or parodic, that haunts its simple tray-like shapes. And, ironically, it is one that Trockel has used to title other works.

Like its fellows, *Less Sauvages than Others No. 2* implies an aesthetic comparison. Which "others" are in question? Presumably both work and title evoke the world of sculpture. But why are its others "sauvages"? To have these implicit questions so recently raised in Brussels, with the inclusion of *No. 2* in Trockel's latest survey exhibition, is to be asked to recognize just how relevant they remain. Let us propose, in light of the Brussels installation, that *Less Sauvages than Others No. 2*, which was shown alongside two equally minimalizing ceramic reliefs, *Training*, 2011 (p. 190), and *Training 2*, 2012, was present to exemplify a less-than-savage sculptural comportment. By these lights, the two *Training* pieces were meant to show us

(11) The idea of a bodily and emotional test is of course offered by this title, which recalls that classic—and mythical—sign of unbearable stress, hair that goes white overnight.

(12) An anonymous reviewer of a show by Rebecca Warren held at the Renaissance Society, Chicago, October 3–December 12, 2010, references the interest, within contemporary ceramics, of "fecal mounds." A work by Trockel, *Pot* (2008), is included among the objects referenced, as is an earlier and necessary precedent, the early 1950s ceramics of Lucio Fontana. See http://art.newcity.com/2010/10/11/review-rebecca-warrenthe-renaissance-society/ (accessed April 2012).

how sculptural excess can be tamed. And so they do. Each has the low-key warmth of a softly glowing eggshell, which in itself has a satisfying neutrality (or lack of savagery). But even more telling are the booklike composition of the earlier work, and the stair-stepping shape of the later. It is as if together the two make the viewer a promise: read me, climb me, and hey presto, any nameless wildness will soon be dispelled.

How wise is it to take Trockel's work at its word? Is this a voice one can trust? Certainly it tries hard to get through to us. As befits an artist who often works in series, various formats and titles recur, *Less Sauvages than Others* among them, and *Training* too. *Louvre* and *Shutter* as well. These titles also identify what above I termed versions or representations of sculptural objects: in other words, works that have specific models in mind. In the case of *Louvre*, it is the form of the mirror, while *Shutter* exemplifies precisely what it labels—if, that is, we are prepared to recognize its windowlike form in a dangerously meaty-looking ceramic slab. The *Louvre* pieces, by contrast, go after Baroque splendor, or what might be left of it, in the wake of the fall. Their mirrored centers are ringed with gloppily glazed anti-garlands, and as for those mirrors, they are quite gothically crack'd. If this is Versailles, the party is over; post-Trockel, little is left. Except, that is, the exuberance of an anti-model, a set of works where "bad" becomes good.

* * *

As I write these words, which readers will soon encounter in an exhibition catalogue, I do not yet know precisely which works that show will put on view. From time to time, much-studied bulletins give me an idea of the latest state of play. The most recent, sent by Lynne Cooke only a month ago, tells me that the artist's studio "is full of artifacts from the realm of natural history, plants, 'taxidermied' animals and the like."[13] As I look around my own study, where catalogues lie open alongside *The Annotated Alice*, and where I have been reading up on the artists and naturalists with whose works Trockel will soon be sharing space, I am well aware that Cooke's dispatches signal further expansions of Trockel's cosmos, which will inevitably ring further changes on the transformation theme. These may well speak back, more directly than ever, to the "models" that, once the exhibition is open, will cohabit with her work. No dodos, apparently, but an image of a flamingo, birds by Castle, and several watercolors by Merian, which surround the specimens they gather with a truly cosmic line.

Cosmic, and perhaps even seismic. Certainly Merian's pursuit of insect metamorphosis not only described, but also lived out, her own commitment to change.[14] Trockel's cosmos too is under the sway of transformation. But more than that, her confidence in her own perspective has produced her increasingly crucial contribution to the changing typologies of art. Which is to say: her insistently unstraightforward work, too, has become an essential model. Every time we meet it, we must learn again to confront its good/bad forms.

(13) Email communication to the author from Lynne Cooke, March 21, 2012.

(14) For a discussion of Merian's unusual career, see Natalie Zemon Davis, *Women on the Margins: Three Seventeenth Century Lives* (Cambridge, MA: Harvard University Press, 1995), pp. 140–202.

FREE ASSOCIATING R.T.

Dore Ashton

I'm astonished at the amount of words Rosemarie Trockel has generated, text upon text, upon text, upon pretext.

And here I go adding yet more . . .

I am reminded of Queneau's *Zazie dans le métro* with the parrot who offers an eternal refrain: *tu parles, tu parles; c'est tout c'que tu sais faire.*

And suddenly I remember Brecht (I always thought of RT as Mother Courage). Poor BB wrote:

> From time to time you have to abandon yourself,
> lose your head and lose your mind . . .

George Grosz wrote that BB loved the color gray.

Says an encyclopedia: By the early 1950s (which was when RT was born), the "economic miracle" was well under way, and "West Germany was one of the world's leading industrial countries." A paradox I'm quite sure RT remarked. One could only make non-sense of this, which RT has always done.

When I first met her many years ago she was, I thought, a rather shy person. But when I saw her through her works, I saw that she was more likely brazen. But she was never ironic. The *eiron* in Greek drama was the one who knew but pretended not to know. She has a few things in common with Magritte whose *ceci n'est pas une pipe* says it all, but *not* his irony.

Does she seek, with Brecht's intensity, the *Verfremdungseffekt*?

Certainly the most recent work I have seen in reproduction, her 2007 *Atheismus*—an overstuffed chair made of wool and felt—is a challenge to sense-makers, and in its way repels, as BB intended his distancing effect to do.

Brecht hated what he called "culinary theater."

But RT, as feminist commentators love to stress, makes numerous culinary allusions . . . all those hotplates that transform themselves into dominoes, and whatever else the spectator wishes to add, not excluding Duchampian scatology (he who once cast a clitoris).

Ben Gurion once chose an Israeli cabinet minister because he had only one arm and therefore could not speak "on the one hand, and on the other . . ."

RT's range defies description and bespeaks a keenly intellectual mind, one that holds in suspension Wedekind, Büchner, Pinocchio, and Goya, among many others, and I suspect, with her interest in animals, Goya's donkeys rate highly in her treasure chest of images. From Strewwelpeter to Gestalt theory, to amusement parks with bumpem and dodgem cars to García Márquez to monkeys . . .

Monkeys, I am told, are monkeys, but chimpanzees are chimpanzees and not monkeys . . .

"The monkey," writes one critic, "is never far from Trockel's drawn dreams."

She is also never far from the rabbit-duck conundrum posed by Gestalt theory.

Who but RT could make wool sinister; could make the act of unknitting significant?

Who can offer fringes as artistic insights, with all the fringe benefits that implies, with total aplomb?

From mockery to idealism, the tones of voice projected by RT can seem inscrutable, unfathomable, incommensurate, illegible, and . . . yes, shocking. In her case it is really true that you can never guess where she will wander next. I am humming to myself: "I wonder as I wander all over this world . . ." For example, I wonder why she calls that overstuffed pseudo-chair *Atheismus*. But then again, why not? And why not sneeze, as one of her masters suggested.

29

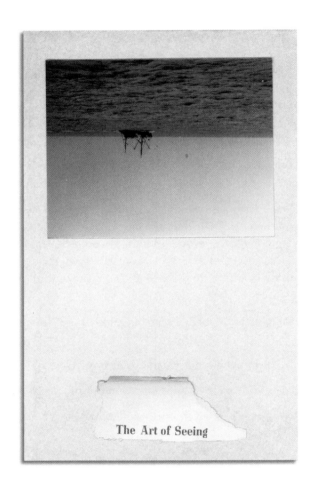

The Art of Seeing

ROSEMARIE TROCKEL

The Art of Seeing, 1980
Collage and photograph on cardboard
21.7 x 13.7 cm

MODELLING A COSMOS

Lynne Cooke

One of the clearest memories from the museum visits of my childhood is of a crab. It was a giant crab, to be precise, which was in a glass case, a quite hard-to-find case, in the Peabody Museum (actually, in the Museum of Comparative Zoology) in Cambridge. As I remember, it was the scale that was so astonishing. I had never seen a crab that size and had therefore not imagined that it was possible. It was not only the size of the whole but of each of its individual parts. One could see the way it was made: huge claws, bulging eyes, feelers, raised bumps of shell, knobbly joints, hairs that extend out around them. ...

I could attend to a crab in this way because it was still, exposed to view, dead. Its habitat and habits of rest, eating and moving were absent. I had no idea how it had been caught. I am describing looking at it as an artefact and in that sense like a work of art. The museum had transformed the crab—had heightened, by isolating, these aspects, had encouraged one to look at it in this way. The museum had made it an object of visual interest.

The museums of Europe have a long history of encouraging attention to objects, crabs included, as visible craft. This was a good part of the rationale of the early museums, those encyclopaedic collections of Renaissance princes. Much has been said of the ideology of power, political and intellectual, engaged in both the collecting of objects and the taxonomic manner of ordering them. But I want to stress that what was collected was judged to be of visual interest. ... Spaces were set aside for the examples of natural and human artifice from around the world. ... In a special class were objects that tested the border between the craft of nature and that of culture, natural artifice and man's—goblets fashioned out of shell, for example, or worked coral. Indeed, painters took up the challenge in their own media: Dürer's watercolor crabs or the painted flowers and shells of Jan Bruegel compete with what nature has made. The visual interest accorded a flower or shell in nature is challenged by the visual interest of the artist's representational craft. Providing paintings of rare flowers and shells for attentive looking in encyclopaedic collections was one way that artists were involved with the museum from the start. ...

The museum effect, I want to argue, is a way of seeing. And rather than trying to overcome it, one might as well try to work with it. ... [My] hypothesis, that everything in a museum is put under the pressure of a way of seeing, ... [entails that] difference from what is customarily seen is a spur to visual attention, while extending a sense of craft. ... [This occurs] particularly if the object was not made for such attentive looking, ... [if it is not] what we would call a work of art. What the museum registers is visual distinction, not necessarily cultural significance.

[M]useums provide a place where our eyes are exercised and where we are invited to find both unexpected as well as expected crafted objects to be of visual interest to us. The mixture of distance, on the one hand, with a sense of human affinity and common capacities, on the other, is ... [a fundamental] part of [this] experience of looking.[1]

I have quoted at unusual length from Svetlana Alpers's essay "The Museum as a Way of Seeing" for several reasons. The authority of Alpers's voice as a cultural historian, as she ranges across a broad swath of European history, is not lessened by recourse to subjective experience: indeed, that formative childhood encounter seems to have proved foundational in developing her thesis of what she calls "the museum effect." The young Alpers did not register the unusual size of the Peabody crab as weird or freakish. On the contrary: its exceptional dimensions permitted every aspect to be viewed in precise detail: "one could see how it was made." Had she found it anomalous and so been overawed, wonder would have kept her at an unbridgeable psychic remove. By regarding it as a representative example of something she had previously known in a related form, though on a smaller scale, she was able to immerse herself in a heightened scrutiny of nature's craft. Alpers's momentous encounter was echoed, fortuitously but tellingly, when, last year, while on a site visit to the Museo Reina Sofía, Rosemarie Trockel discovered a rare Japanese spider crab (*Macrocheira kaempferi*) on display in Madrid's natural history museum. Like Alpers, Trockel became fascinated by the huge specimen in all its compelling detail.

The epicenter of *Rosemarie Trockel: A Cosmos* (as realized at the Museo Reina Sofía) is a small gallery devoted exclusively to Trockel's work, old and new: with its curious mixture of the fantastical, erotic, and perverse, the "Ceramic Room" recalls a Wunderkammer.[2] By contrast, the remaining galleries of the exhibition—whose exhibits comprise artefacts, natural and human—have been arranged typologically, as in a traditional natural history museum, or thematically, as in many museums of modern art. Inviting a heightened scrutiny, item by item, the works in these galleries ground viewing additively in the specific and the particular, the concrete and the crafted. If the sensory overload of the Ceramic Room's oneiric mise en scène encourages a synoptic overview, a prelude to reverie, the temperature is lower, so to speak, in those rooms where the viewer's regard is slowed and more searching.[3] Far from being teased and provoked by the Wunderkammer's surrealistic spirit, the spectator is there permitted to proceed at her own pace, to meander, letting her gaze explore in painstaking detail whatever claims its attention. These very distinctive installation strategies generate fundamentally different ways of apprehending. Deploying all three types of

(1) Svetlana Alpers, "The Museum as a Way of Seeing," in *Exhibiting Cultures: The Poetics and Politics of Museum Display*, Ivan Karp and Steven Levine, eds. (Washington D.C.: Smithsonian Institution Press, 1991), pp. 25-32.

(2) Treasure troves of the singular and exceptional, cabinets of curiosities typically contained anomalous and wondrous artefacts, natural and manmade. Though it evolved from the Wunderkammer, the modern museum was, by contrast, shaped by Enlightenment ideals of rational order and progress, forms of systematic classification and taxonomy, and modes of intellectual enquiry based in scientific knowledge.

(3) Surfaced with a regular grid of white tiles, and lit with a sharp, cold, white light, the décor is reminiscent, according to the artist, of an old-fashioned butcher's shop. It also evokes a clinic or laboratory. Though Trockel did not interpret this invitation as an opportunity to pay homage to mentors, allusions to such artists as Marcel Broodthaers, Marcel Duchamp, and Blinky Palermo, among others, may be found both in individual works she has produced for the exhibition and in certain of the exhibition strategies she adopted.

installation convention, the exhibition traces an historical lineage from the Wunderkammer, through the Enlightenment-inspired natural history museum, to the modernist museum with its paradigmatic white cube galleries. Inevitably, the emphasis falls on that mode of looking Alpers identifies as integral to "the museum effect."[4] "The taste for isolating this kind of attentive looking at crafted objects is as peculiar to our culture as is the museum, as the space or institution where the activity takes place," she claims.[5]

The appreciation of craft inherent in this highly specific, institutionally-sited mode of perception comes to the fore in this exhibition in a trio of galleries organized by reference to materials: ceramics, textiles, and books. Such a focus highlights Trockel's versatility in addressing materials both as mediums and as art forms in their own right. On occasion, she engages with clay as the material best suited to close copying, that is, in its traditional role in reproduction and replication: in the monumental double sofa *Replace Me*, 2011 (p. 115), for example, the ceramic cast is so meticulous as to defy belief that it is in fact a replica and not the original worn leather couch. Conversely, at its most basic—as inchoate matter or materia prima—clay becomes the stuff of the grave (*Spiegelgrab*, 2006; p. 180) or the organic substance from which primitive organisms evolve (*Made in China*, 2008; p. 183). Remarkable, too, is the fertility with which she has engaged since 1985 with wool, often considered her signature material. The large and diverse repertoire of works included here ranges across *From a French Magazine*, 2005 (p. 142), photographs in which humans imitate manikins as they model clothes; *À la Motte*, 1993 (p. 147), a video in which a moth carves a route through a piece of fabric then reverses its destructive impulses; *My Dear Colleagues*, 1986 (p. 140), a sweater conceived around a plastic coat hanger; and an untitled work from that same year, a knitted flag that is unravelling into its constituent balls of red, white, and blue wool (p. 145). Within this plethora, Trockel's signature knit paintings—the works with which she first made her reputation—are present only obliquely.[6] *Untitled (For those who don't like wool pictures but are communists nonetheless)*, 1988 (p. 149), among the earliest works on view, and one of the few seemingly conventional paintings in the exhibition, is a small white monochrome with a square format. Beneath the canvas, which has been covered with a layer of gesso, is a piece of machine-knitted wool fabric. Only a slight ridge near the upper edge of the canvas betrays it presence. Does this constitute subversion from within? Or a passive-aggressive withholding? Recourse to commercial techniques of production along with the use of trademarks and logos was integral to Trockel's critique of the devaluing of materials and methods associated with craft and the decorative arts long standard within modernist discourse. At the same time, her adoption of an industrial form of fabrication questioned essentializing paradigms advocated by those branches of '70s feminism that revelled in the stereotypically handcrafted, the personalized "woman's touch," and the like. In recent years Trockel seems to have reversed course and commissioned hand-knitted fabric from which she has generated such comically oversized paintings as *Sky*, 2012 (p. 166), and *Kind of Blue*, 2012 (p. 167). She has also fabricated monochrome wool paintings by aligning

(4) This is not to deny that elsewhere within the show, Trockel stages certain groupings of work for dramatic impact: see, for example, the juxtaposition of *Atheismus*, 2007, *Reborn with Spot*, 2011, *Daily Trap*, 2010, and *Geruchsskulptur 2*, 2006 (pp. 171, 114, 186, and 187, respectively).

(5) Alpers, op. cit., p. 26.

(6) Note, too, the fragment of knitted fabric with the trademark wool sign uppermost in the stack of textiles filling the pedestal in *Lucky Devil*, 2012 (p. 102).

single strands of yarn, stretched edge to edge across the canvas surface, to create graphic accents within monochrome fields that recall, inter alia, abstract paintings by Agnes Martin. The repetitive "wrapping" of the object—the stretched canvas—with yarn in such works as the trio titled *Black Cab*, 2011 (p. 159-60), resonates with techniques that Judith Scott devised to create artefacts whose armatures—provided by miscellaneous found objects, leftover pieces of lumber, generic vessels, and domestic implements—were sheathed in textile skins. Six vibrantly colored tactile sculptures have been installed in dialogue with Trockel's most recent knit works.

The interrelationship of skill and craft foregrounded in this apparently guileless juxtaposition serves a rhetorical purpose: it pinpoints the question of "making"—of fabricating and crafting, that stretches across a spectrum from the meticulous arcane techniques of the professional artisan to the repetitive mundane methodologies adopted by the self-taught—central to this exhibition. Trockel's complex, unpredictable, canny, and disarming modalities are evident in virtually all the many different art forms with which she engages but perhaps nowhere more intensely than with drawing, evidenced here in an open-ended series of book drafts that now spans the full compass of her career. Though several of the earliest of these works were maquettes for publication, the vast majority were never burdened with a functional purpose: as the term "drafts" suggests, their role approximates that of sketches. "Like many artists before and around her, Rosemarie Trockel has perfected an approach to drawing that knows exactly what it aims to disavow," Anne Wagner contends. "[N]othing in her way of proceeding bespeaks a careful honing and husbanding of a range of graphic skills. ... All of this results in works that, although they do observe the technical conditions of drawing, in using the requisite media, formats, and scales, still display a pretty strict avoidance of familiar graphic pleasures and thrills. ... What all these works share of *drawing* as 'signature marking,' that is to say, is their maker's studied effort to dodge or duck the look of skill."[7] In parallel with Trockel's efforts to disavow signs of skill, the issue of technical ability proves moot in the case of Scott: though often her improvised technique seems perfunctory—nothing more than what was needed to cover the inner skeleton, to create a situation, protective and covert, for what lies within—on occasion, as in the gorgeous piece with a field of knots adorning one of its sides, her means expand beyond the rudimentary to a mastery of decorative effects. Irrespective of whether it is the outcome of sophisticated artifice, or of sheer practicality, the baseline for Trockel and Scott is very similar: the minimal means required to secure the desired ends.

Prioritizing a heightened attentiveness that engages the crafting of any object—organic, or made by animals or by humans—*Rosemarie Trockel: A Cosmos* underpins Alpers's provocative claim that "what the museum registers is visual distinction, not necessarily cultural significance." The selection and installation of objects created by individuals not normally recognized as artists, or for functions beyond the strictly aesthetic, call into question the ways in which cultural relevance is conventionally, even automatically, assumed to inhere in arte-

(7) Wagner, "Difference and Disfiguration: or Trockel as Mime," in *Women Artists at the Millennium,* Carol Armstrong and Catherine de Zegher, eds. (Cambridge, MA: MIT Press, 2006), pp. 305-6.

facts presented within an institutional context. In turn, it offers a corrective to those types of expository exhibition and collection display, conceived from an ideological position or as didactic historical narratives, in which art objects serve primarily as place markers to stake out a conceptually driven argument. By grounding viewers' experience in visual scrutiny and hence privileging what Alpers calls "visual distinction," Trockel's project offers a heuristic model for probing the terms in which exhibition-making originates, and the ways and means by which cultural value is assigned.

"Elective affinities" may best describe how Trockel characterizes her relations to the contributors to her cosmos. Neither the recuperation of eclipsed careers and of marginalized individuals, nor the reclassification of works formerly within the realm of the natural sciences into that of art history, ever was articulated as a goal of this curatorial endeavor. However, since the overturning of traditional disciplinary categories has become almost routine in her practice, it is not surprising that such reversal may be among its significant side effects. The (invidious) practice of ranking artistic achievement is a subject that offends Trockel, who mocked it with painful, mordant irony in her 1994 video *Continental Divide*. It is nonetheless a subject that any established artist, and particularly one with a deeply grounded feminist perspective, cannot avoid in today's competitive art world. In her landmark essay "Why Have There Been No Great Women Artists?" published over forty years ago, the American art historian Linda Nochlin enjoined her readers not to be led astray with surface issues, that is, with efforts to elevate or revaluate individuals within a given pantheon, but to burrow into the "vast dark bulk of shaky *idées reçues* about the nature of art and its situational concomitants, about the nature of human abilities in general and of human excellence in particular, and the role the social order plays in all of this."[8] Though she may not consciously articulate it in precisely this manner, such forms of enquiry galvanized Trockel's practice from its outset.

<p style="text-align:center">*　*　*</p>

Hindsight brings to the fore certain aspects of this selection that were hitherto understood more intuitively. Trockel's own works aside, many of the artefacts displayed here originated within the realm of natural history. Almost all were created in the period stretching from the late seventeenth through the mid-nineteenth century; that is, in an era in which enormous and rapid developments were being made in the fields of botany and zoology as a consequence of imperial expeditions. "Natural history was reconceived in this period," art historian Elizabeth Cropper contends, "as the examination and experience of knowledge, not the compilation and reconciliation of authorities."[9] Detailed personal observation became the basis on which the adolescent Maria Sibylla Merian discovered the metamorphic

(8) Quoted in Maria Dibbattista, "Scandalous Matter: Women Artists and the Crisis of Embodiment," *Women Artists at the Millennium,* op. cit., p. 427. While addressing specifically the situation of women artists, Nochlin's recommendations can be used heuristically to explore the predicament of other disadvantaged and marginalized groups.

(9) Elizabeth Cropper, "Preface," *The Art of Natural History: Illustrated Treatises and Botanical Paintings,* Therese O'Malley and Amy R.W. Meyers, eds. (Washington D.C.: National Gallery of Art/New Haven: Yale University Press, [2008] 2010), p. 7.

life cycle of moths and butterflies several decades before established scientists, who depended more on textual authorities than on experience gained through field work, thoroughly understood this phenomenon. Executed while still a teenager, the three exquisite, precise studies from the Staatliche Museen in Berlin of caterpillars and pupae, which she herself had bred, attest to the critical role of an avid curiosity coupled with acute and patient observation in shaping Merian's vision. Fundamental to her research method, heightened observation was complemented by the extensive artistic training that she received from her father and stepfather (respectively, an engraver and a painter of flowers). Merian's exceptional formation was crucial to her groundbreaking contributions to entomology and lepidopterology as well as to the history of art. The spirit of intellectual independence that governed her adventurous life may also have influenced her decision to organize the material she brought back from a two-year research trip to the jungles of Suriname according to a personal intuitive method of ordering rather than in conformity with prevailing disciplinary conventions.[10] Perhaps for this reason, her books, even the remarkable *Metamorphosis of the Insects of Surinam*, based on watercolor studies made on that extended field trip, were later eclipsed by more mainstream texts.

Exceptional circumstances—in this case relating to his failure to publish opportunely the results of his findings—served also to sideline recognition of the contribution of José Celestino Mutis to the history of botanical discovery. When in 1783 Mutis finally gained permission to lead a royal expedition in New Granada, he trained his assistants and associates in both fieldwork and in the documentation of the plants they retrieved from its various climactic zones. At the school he established there, at Santa Fe, in the 1790s, the nearly forty artists who would enter his employ over some thirty years executed 6,700 drawings according to the detailed guidelines he formulated. These required, for example, that each specimen be reproduced on a one-to-one scale; that the plant be centrally placed on the page; that the more malleable parts, such as the tendrils of a creeper, be arranged in symmetrical arabesques on either side of the main stem; that the overall form be flattened rather than rendered volumetrically; and so forth. So well did the artists absorb his distinctive methodology that it is often impossible to identify the hand of an individual draftsman if a sheet is not signed. In choosing examples from among this vast collection almost never exhibited outside the precincts of the Archivo Real Jardín Botánico in Madrid where it is now housed, Trockel indicated a clear preference for spare, delicate, single-stemmed plants. In several instances, because a specimen was considerably larger than the dimensions of the given sheet of paper, the draftsman has bent the stem into a series of elegant repeating curves in order to convey accurately its exact length. Conforming to the requirement of faithfully documenting the unknown and unconventional, his inspired decision produced aesthetically striking results. While there was nothing quixotic about Mutis's formulation of the conceptual schemata, when considered within the histories of botanical illustration, their style at times is markedly at variance with canonical representations. Unaware of the conventional disciplinary evaluations that today rank Mutis's

(10) Merian's voyage to Suriname with her daughter in 1699 to study the native flora and insects was likely the first expedition undertaken by Europeans for purely scientific research.

images when she made her selection, Trockel favored examples that have, to date, escaped the regard of professionals in this field.

The family business run by Leopold and Rudolph Blaschka serviced both academic research and pedagogy, in the form of educational displays in museums dedicated to the natural sciences. Working together for some thirty years, father and son provided exactingly accurate models of marine invertebrates and, later, of rare species of plants and flowers, otherwise unavailable for study (for such fragile specimens lose form and color when immersed in preservatives or when flattened and dried for herbaria). Still not fully understood, or surpassed, the technically ingenious, personalized methods the Blaschkas invented in order to fabricate these intricate scale models brought their work into high demand in institutions throughout Europe and the United States. Though today superseded as research tools, and little more than a footnote in the history of science, their fragile artefacts have attracted a wide audience inevitably thrilled by the extraordinary craftsmanship and limpid beauty. Dürer and Bruegel were among the artists Alpers instanced when discussing the fact that "the visual interest of the artist's representation" might challenge that of nature: the Blaschkas clearly deserve a place in this august company.

So, too, does John James Audubon. Unlike the glass sea creatures, his watercolor studies of birds, on which the monumental multi-volume publication *The Birds of America* (1827–1838) is based, won broad public acclaim from the moment it was launched. Landmarks in the history of the natural sciences, they mark the end of a great exploratory era. Confronted by vast quantities of newly discovered material, both flora and fauna, dedicated individuals who, in large part, were self-trained, were able to make major contributions to their field on the basis of careful and patient observation and skilful, detailed rendering. Direct experience, combined with a modest knowledge of dissection and access to basic technical equipment (that in few instances extended even to the possession of a microscope), were the fundaments on which they assumed the role of naturalist, professional and amateur alike. Trockel's reprise of that historic era takes the form of a number of works created expressly for this project. Recourse to ready-to-hand technologies is among their hallmarks: for example, *Picnic*, 2012 (p. 82), a grandly scaled domestic shadow-box, arrays a panoply of strikingly sculptural vegetal forms as if on the shelves of old-fashioned display case. Both the witty *Paws Down*, 2011 (p. 68), and *Go Away Bird,* 2011 (p. 2), were shot on the artist's iPhone. A stuffed turaco from South Africa that she recently acquired and that currently presides over her studio, the Go Away Bird, as it is familiarly known, has been silhouetted on a white ground. Digitally detached from its habitats, former and recent, it becomes a specimen. Hovering in limbo, literally and figuratively, as do so many works in Trockel's cosmos, it too negotiates the traditional art/science divide.

Like Trockel, Mary Delany relied on the fruits of her garden (as well as of those of her friends) when sourcing her specimens. As a female member of the British aristocracy, Delany is unlikely, however, to have considered the career of a professional artist. Destined at a young age to a marriage of convenience with an elderly infirm spouse in order to secure her family's financial well-being, Delany had neither the means nor the opportunity to consider an independent life shaped by her own desires. Only after she was widowed for the second time did this well-educated, sophisticated woman achieve a measure of economic and social autonomy. At the age of seventy-two, and largely for her own pleasure,

she devised a novel method for making flower studies. Coloring, cutting, and collaging up to several hundred pieces of paper, she portrayed each specimen against a dark ground, produced by lightly washing black ink over the surface of a standard sized sheet of paper. Botanically accurate, her corpus of 995 studies of species both local and exotic, executed over a decade beginning in the early 1770s, reflects the interests of a scientifically minded community to which she belonged, comprised of such luminaries as the botanist Joseph Banks; her patron, the Duchess of Portland; and several experimental gardeners and renowned horticulturalists. Known only to the members of her intimate circle during her lifetime, these works were eventually donated to the British Museum's Department of Prints and Drawings, where they remained largely unnoticed for almost a century. Though they have attracted widespread interest over the past decade, this has not come primarily through scientific or even aesthetic channels: modest are the claims made for her "paper mosaicks" within the histories of art and the natural sciences. Despite inventing a novel technique for the representation of often little-known subject matter, Delany could never have been considered an artist in her day: both her class and her sex would have told against her. Equally, her lack of professional training in the higher art forms, painting in particular, and the lowly status of her chosen subject matter would have precluded such recognition. The flood of recent scholarly and public attention is due largely to her en-thralling biography, as the titles to two influential publications intimate: "Mrs Delany (sic) and Her Circle"; and "The Paper Garden: An Artist [Begins Her Life's Work] at 72."[11] While anachronistic, the classification of Delany as an "outsider artist" avant la lettre might help elucidate the terms and the tone in which the work of this gifted amateur is currently appraised: rather than the wondrous product of singular circumstances, she is a maverick contributor to the study of botanical illustration within a multivalent art history.

Among the constellation of artists in *Rosemarie Trockel: A Cosmos* are several others whose work tends to be categorized along similar lines: Morton Bartlett, Judith Scott, and James Castle. While usually a synonym for "self-taught" or "autodidact," the label "outsider" is highly problematic in and of itself. In the context of this exhibition, where manual skills and craftsmanship are foregrounded yet divested of hierarchical signification and value, such terms are rendered void or meaningless. A successful commercial photographer and graphic designer, Morton Bartlett characterized his self-directed work as Delany might have, that is, as a hobby. Teaching himself to sculpt in plaster and then to sew, he created a "family" of children, fifteen young boys and girls of varying ages, at one-half scale, that he dressed in a variety of handmade costumes and photographed in vividly affecting terms. Through his study of anatomy books and costume histories over some thirty years, Bartlett endeavored to make his figures seem as lifelike and historically specific as possible. Also like Delany, he never sought a wide public: his primary aim, he stated, was "that of all proper hobbies—to let out urges that do not find proper expression in other channels."[12]

(11) See *Mrs Delany and Her Circle,* Mark Laird and Alicia Weisbery-Roberts, eds. (New Haven and London: Yale University Press, 2009); and Molly Peacock, *The Paper Garden: An Artist [Begins Her Life's Work] At 72* (New York: Bloomsbury, 2010).

(12) Quoted in "Morton Bartlett," Udo Kittelmann and Claudia Dichter, eds. (Berlin: Hamburger Bahnhof, 2012), p. 80. Shortly after their posthumous discovery in 1993, the figures were exhibited in a contemporary art context where they immediately aroused considerable interest from artists as well as other art professionals. The fact that the context in which they were first made public was an antiques fair underlines their ambiguous character.

An autodidact who worked in isolation from professional art circles throughout a long and productive life, James Castle seems to have produced his numerous drawings, handmade books, and constructions stitched together from found paper and card solely for his own ends. While he occasionally showed drawings to relatives or to visiting family friends, to solicit their approval, he never revealed the existence of his extensive corpus of books and constructions. Since many of the latter have strings from which they can be hung, they may, however, have been incorporated into exhibitions he staged (perhaps only in his imagination) in an empty room, perhaps a barn or chicken coop, on his family's farm in rural Idaho. Based on his memories from childhood and early adulthood, Castle created a private universe, an absorbing world of keenly observed and subtly rendered images and objects. Defying conventional prescriptions, he evolved, by himself and for himself, a sophisticated understanding of what is involved in systems of representation and what it is to practice as an artist within contemporary culture.[13]

Like Castle, Scott could not hear, read, speak, or write, and like him, her creative expression was obsessive and inner directed. Only after being admitted in the 1990s to the Creative Growth Art Center in Oakland, an institution which supported aesthetic expression in individuals with disabilities, did Scott evolve her particular technique. Working independently of others at the center, over a period of fifteen years she produced a variety of objects, all wrapped in wool, yarn, or strips of fabric. Sometimes taking several months to realize, each work, distinctive in form and palette, was clearly identified as finished. Once she judged a piece completed, Scott never returned to it; putting it aside, she began the next.

In contrast to Bartlett, Castle, and Scott, who were indifferent to the mainstream art world, the Spanish artist Manuel Montalvo took a deliberate decision to opt out of it. Trained as a painter in Paris in the mid-fifties, he quickly gained attention for the works he showed in exhibitions in his native country. Seemingly overwhelmed by such recognition, Montalvo quit this scene and spent most of his working life employed in the commercial ceramics industry. Only after retiring did the increasingly reclusive draftsman begin to produce small volumes illustrated with hundreds, even thousands, of drawings. Combining the form of an atlas with that of an encyclopaedia, the first of these treasure troves of taxonomically organized images and texts was conceived as a gift for a young niece. But as their extreme miniaturization effectively undermined their use-value, his handmade books soon took on an independent life. With his unerring line and extraordinary memory for detail and diversity of form, Montalvo gave free rein to a fecund imagination laced with a refined visual wit.[14]

Within the exhibition's diverse panoply of historic and contemporary figures, another subgroup, comprised of the under-recognized or neglected artists Ruth Francken and Günter Weseler, could be proposed. (Since this posthumous presentation of of Montalvo's books marks their public debut, he could also be considered within this company.) The appreciative lens through which Trockel views the works of unaligned or marginal creators

(13) Castle's work entered the mainstream art world some twenty years after his death in 1977: like Bartlett's, and later Scott's, his work too made a rapid segue from circuits dedicated to "outsider" art into a contemporary art discourse.

(14) Though he was greeted as something of a prodigy and quickly received a measure of critical recognition, there is little literature on Montalvo's brief professional career.

means that neglect in professional circles may, for her, evidence the independence, the singularity, of their visions. While the Paris-based Francken exhibited consistently in public and private galleries in France and elsewhere from the late '50s, by the time of her death in 2006 her audience had dwindled. Though the sculptures and reliefs she made in the end of the sixties through the mid-seventies, featuring motifs like a telephone or a pair of scissors, have in the last decade attracted attention, particularly among feminists, in later life neither Francken nor her renowned apologist, Jean-François Lyotard, seems to have highly valued them compared with her paintings, early and late.[15] Neither discusses these works in any detail. Yet to a contemporary eye such as Trockel's, there is something strangely haunting in their melding of a perverse eroticism, proto-feminist spirit, and technological fetishism. Weseler's reputation remains largely that of an "artist's artist," that is, his work is known to an inner circle of cognoscenti but seldom beyond. Trockel first encountered it as a young artist, at a time when Weseler was exhibiting frequently in the Rhineland. Through both mechanical and natural means, his signature sculptures impart a vestige of organic life to abstract forms, suggesting how easily the realm of the natural sciences elides with that of science fiction. Trockel's growing interest in his modest works, at once disturbing and compelling, led her to invite Weseler to collaborate with her on a work for this exhibition: *Fly Me to the Moon*, 2011 (pp. 136–37).

* * *

The seeds of this exhibition lie in a dialogue I have had with Trockel over many years. Formally, the project began two years ago when I invited her to collaborate on a show that would reflect or embody her cosmos. In asking her to consider constructing a pantheon of works that were crucial to her imaginary, I hoped that the artefacts we selected would elucidate her multifaceted practice in fresh and unprecedented ways when seen in tandem with examples of her own work. In lieu of a more conventional retrospective likely to prove neither welcome to an artist who constantly dodges iconic forms of presentation, nor a useful model through which to gauge her shape-shifting repertoire, I hoped this unprecedented form might illuminate a practice that, too often, is regarded as enigmatic or incoherent—in short, impossible to corral and define. Once we began to discuss what might be the constituents of this cosmos, parameters quickly emerged. Not surprisingly, given that it had been agreed from the outset that Trockel's own works would provide the nucleus of the project, certain of her abiding concerns proved key to its shaping: her longstanding interest in natural history; her persistent challenge to conventional hierarchies among art forms; and her deep-seated interest in diverse forms of creativity, whether of the trained professional or the self-taught artisan, or seen in modes of aesthetic expression particular to other species.[16]

(15) See Ruth Francken, "Connections," n.d., http://www.costis.org/x/francken/connections.htm (accessed May 2012), and J. F. Lyotard, "The Story of Ruth," 1983, http:www.costis.org/x/francken/story.htm (accessed May 2012). Much of Francken's work is difficult to trace following the sale of her estate at auction (Drouot Richelieu, Paris, September 20–21, 2007). *Eros et civilisation*, 1972, was included in 2009 in *Elles*, the presentation of the collection of the Centre Georges Pompidou devoted to the work of twentieth-century women artists, where it was first seen by both Trockel and Cooke.

(16) In 1993, for example, Trockel titled an exhibition and

Trockel's practice has long been informed by a subtle but charged feminist perspective that expresses itself through wit, irony, and an astringent self-scrutiny. Constantly avoiding the didactic and illustrative in favor of a probing poetics, it delights in punning, mockery, and other forms of visual and verbal play. Her works consequently range from the strangely haunting to the wryly comic, from the grotesque and ridiculous to the sentimental and pathos-ridden, from the whimsical to the ludic. As we honed the checklist, evidence of her distinctive sensibility increasingly came to the fore. Thus, for example, she arranged three paintings, executed by an ourangutan that she had purchased some years previously, to form a triptych and then enclosed the right-hand panel within a perspex frame. One of a number of pieces that bear the title *Less Sauvages than Others*, the resulting artefact is now identified as a work within her own oeuvre.[17] And she acquired a large crab, presumably in anticipation of its potential to dialogue with the *Macrocheira kaempferi* we had requested from the natural history museum in Madrid: *Lucky Devil* was the name she eventually bestowed on "her" crustacean. In addition, she repurposed material generated several years before. *Park Avenue*, 2006 (pp. 80–81), is a slide-piece containing images of whimsical creatures (composed from botanical fragments collected in a local park) that she had once planned to use as illustrations for a children's book. *Reborn with Spot*, 2011 (p. 114), commissioned from a Vietnamese company that specializes in copies of oil paintings, is based on a work by Toulouse-Lautrec, which she knew from an old catalogue was likely in the collection of the Wuppertal art museum though it had not been exhibited for decades; on receiving the well-executed replica she added a "beauty spot." Up until the exhibition's opening in Madrid, additions were made to the checklist as she generated an impressive array of new works. The search to unearth additional participants also continued apace: it too was halted in medias res by the show's deadline. "Discovered" too late to permit their inclusion in the presentation in Madrid, examples of Delany's flower studies will join the exhibition tour, for, in addition to expanding idiosyncratically on the subject of botanical illustration, they provide a revealing historical gloss on issues concerning the identity and status of the artist that have emerged as central to this project. As of now, the project comprises almost eighty works by Trockel and some sixty by the fifteen other participants.

Counterposing the Ceramic Room, with its heady mixture of the erotic, exotic, and uncanny, the two adjacent low-lit galleries, banded with a dark grey painted dado, contain exhibits pertaining to the natural sciences by Merian, the Blaschkas, Robert Havell (who engraved Audubon's watercolor studies for *The Birds of America*) and from Mutis's expedition to New Granada. Also part of this dense matrix are several of Trockel's works: drawings

accompanying book *Jedes Tier ist eine Künstlerin* (Every animal is a [female] artist) (Anders Tornberg Gallery, Lund). In an unusually macabre gesture, she superimposed a large black spider on the pudenda in her 2011 reworking of Courbet's erotic masterpiece, titled *Replace Me*, thereby making it the very centre of *L'Origine du monde*.

(17) Trockel declared in an interview in 1988: "I am interested in the monkey as man's imitator—or as an imitator on its own, pure and simple." Cited in Melitta Kleige, "The Power of Expectation," in *Rosemarie Trockel: Bodies of Work 1986–1998* (Cologne: Oktagon Verlag, 1998), p. 63, n.1.

Monkeys and apes have long interested her. See also Anne Wagner, "Difference and Disfiguration, or Trockel as Mime," in *Women Artists at the Millennium,* Carol Armstrong and Catherine de Zegher, eds. (Cambridge, MA: MIT Press, 2006), pp. 304–25). "For Kleige," Wagner writes, "Trockel uses the monkey 'as a means ... to reflect and recognize herself as a human being and an artist.' In my account, the monkey as the figure of imitation offers Trockel the means to represent difference and distance—what is unknowable about another self." (p. 325)

and photographs of plant forms and a luscious red ceramic, *Touchstone*, 2012 (p. 182), that recalls an out-size shellfish. In this context Salvador Dalí's *Aphrodisiac Telephone*, 1936 (p. 126), sheds much of its surrealistic aura to reveal an often overlooked genealogy reaching back to the opulent nautilus cups fabricated in the later seventeenth century and after, and similarly freighted with a sophisticated blend of natural and human artifice. But whereas the Baroque goblets were the product of exquisite workmanship and rare materials, Dalí's tour de force depends on a brilliant coupling of mundane objects: as such, it retains the conceit, while forgoing the labor-intensive fabrication of its predecessors. Here, too, Wladyslaw Starewicz's pioneering animation film, *The Cameraman's Revenge*, 1912 (pp. 108–10), found its rightful place. An entomologist by training, Starewicz had serendipitously discovered the technique of stop-motion animation when attempting to document stag beetles fighting. A classic tale of love, betrayal, and vendetta, his early masterpiece is set within the realm of insects. With its beguiling protagonists constructed from the carcasses of beetles, their legs and mandibles affixed with wax, Starewicz's work merged the dual roots of cinema (and of subsequent moving image technologies) in fantasy and documentary. It heralds Trockel's long-standing interest in video, which she deploys to multiple ends, as seen in the trio of works involving animation, time-lapse photography, textiles, insects, abstraction, and performance, installed elsewhere in the exhibition: *Patti*, 2000 (p. 146), *À la Motte*, 1993 (p. 147), and *Pausa*, 1999 (p. 148). From this strategically determined, intimate nexus of galleries, the historical axis of the exhibition unspools into a series of larger white-cube spaces, each dedicated to a single subject or field of enquiry: the domestic, textiles, ceramics, and books.[18]

The imaginary world limned in *Rosemarie Trockel: A Cosmos* is meant to be neither definitive nor exhaustive: just as the territory it maps remains, in principle, open to new discoveries, so individual works may be considered metonymically, as representative of fields of knowledge and experience. If the stringent selection of the artist's own works proves critical in structuring the terms in which this universe is read, the conceptual constants that underpin Trockel's vision account for its coherence and cohesion: they filtered and orchestrated the range of material brought to her attention. *Kosmos* was the title given by Alexander von Humboldt to his culminating work, a multivolume magnum opus published between 1845 and 1862. In his treatise, a universalizing overview of the natural sciences in relation to geography, the famed explorer, naturalist, and scientist singled out the achievements of Columbus. Well aware that the Spaniard was not the first European to discover the New World, when awarding Columbus the palm Humboldt made his decision on philosophical grounds: the real discoverer, he believed, was the one who opened new frontiers of knowledge. Though it did not determine the exhibition's title, this anecdote about one of the greatest figures in German cultural and scientific history repeatedly came to my mind as the project evolved. At one moment, quite early in our discussion, Trockel proposed—only

(18) Given that the show will tour, these categories are somewhat porous, and the installation procedures flexible in order to accommodate differences in the distribution and size of galleries at subsequent venues. Conceived as a complement to the exhibition, this publication has been organized into related thematic chapters.

half-playfully, I suspect—an alternative title: "Influenza." Combining allusions both to "influence" and "contagious illness," her suggestion alludes to the wealth of resonant relationships that may be drawn amongst its exhibits: to the transmissions or flows that affect, shape, and form the whole; and to the infectious spirit with which she so generously threw herself into this project. "From Bruegel's time to that of Cézanne and Picasso, museums have been a school for craftsmen and artists," Alpers reminds us.[19] In her response to this invitation Trockel has ventured, with characteristically light touch, that artists today might school museums. Too often the modern institution assumes automatically—without a self-reflexive questioning—that its primary function is to determine cultural significance. Her intervention suggests that it is time to step forward and scrutinize closely the artefacts we choose to put on view and only then begin to debate the larger authority structures that assign them cultural value.

(19) Alpers, op. cit., p. 26

ROSEMARIE TROCKEL

Ceramic Room (detail), 2012

Rosemarie Trockel
1952, Schwerte, Germany

Rosemarie Trockel was born in the small German town of Schwerte, in the Ruhr, in 1952. Between 1974 and 1978 she studied painting at the Werkkunstschule in Cologne under Werner Schriefers. In 1983 she had her first solo shows at the Monika Sprüth Galerie, Cologne, and the Galerie Philomene Magers, Bonn, where she presented sculpture. By the late 1980s Trockel had garnered an international reputation based primarily on her signature machine-knitted wool paintings, featuring motifs such as logos (the wool mark, a hammer and sickle, the Playboy Bunny) and trademarks, notably, "Made in Western Germany." With her close friend and gallerist Monika Sprüth, Trockel was centrally involved in the launch of a magazine, *Eau de Cologne*, in 1985, and several eponymous exhibitions that featured works by a select group of artists including, beside herself, Ina Barfuss, Jenny Holzer, Barbara Kruger, Anne Loch, and Cindy Sherman. Trockel's first substantial museum show, co-organized by the Institute of Contemporary Art, Boston, and the Art Museum of the University of California, Berkeley, toured in North America before being presented in Madrid at the Museo Nacional Centro de Arte Reina Sofía in spring 1992. By then a number of Trockel's abiding preoccupations were well-established: a refusal to accept traditional hierarchies that elevate the fine arts above the applied and decorative arts; a fascination with diverse forms of creativity, from the trained professional artist to the self-taught practitioner, as well as the aesthetic expressions of other species; and a broadly based interest in natural history, encompassing zoology, botany, and mineralogy. Drawing on a remarkably heterogeneous range of materials—from wool to ceramic and bronze to found objects—and working in a range of mediums, including collage, photography, video, assemblage, and art based in appropriation—Trockel has evolved a poetic mode (as opposed to a literal or didactic one) in which wit, whimsy, and irony play significant roles. A love of punning and verbal/visual play imbues her work, most evidently in her vast body of drawings and the ongoing series of book drafts. Threaded through her remarkably diverse and shape-shifting corpus is a subtle yet charged feminist perspective that frequently manifests itself in terms of a dark humor that no more spares the artist than it does the denizens of her world. Who else but Trockel would title a mid-career retrospective "Post Menopause"?

Since the late 1990s Trockel has worked extensively with clay to make ceramics of a characteristically broad range of types: figurative sculpture, pots, abstract forms reminiscent of shellfish, crustaceans, and other marine life forms, plus some of her most monumental works to date, including *Replace Me*, 2011 (p. 172), based on a double cast of a modernist sofa. Monochrome "paintings" made from wool, both hand- and machine-knitted, continue to play a substantial role in her current production. Throughout her career Trockel has also made short videos, many of which involved collaborations with friends and colleagues, musicians, composers, and actors. She has created a notable body of work addressed particularly to children in the form of projects, autonomous artefacts, and complete exhibitions. For this exhibition, Trockel both collaborated on the selection of works with curator Lynne Cooke and made a body of new work.

Morton Bartlett
1901, Chicago – 1992, Boston

Morton Bartlett's haunting group of fifteen plaster dolls has attracted much attention since they were posthumously discovered, along with a trove of black-and-white photographs, in 1993. Painstakingly modeled and painted, the highly naturalistic sculptures, like the ballerina included in this exhibition, have long been interpreted as a surrogate family for their creator, who was orphaned at age eight. Bartlett was adopted by a Boston family and educated at Phillips Exeter Academy and Harvard University. He was not trained as an artist, though he worked as a commercial photographer, among other creative jobs. The dolls and his photographs of them remained largely a private obsession. The numerous small black-and-white photographs, together with more recently discovered color slides, support the view that Bartlett produced his sculptures not so much as finished works in themselves but as subjects for his camera.

John James Audubon
1785, Les Cayes, Saint Domingue [now Haiti] – 1851, New York

John James Audubon, the French-American ornithologist, naturalist, and painter, is renowned for his finely detailed watercolor studies of birds published, in sections, as *The Birds of America* between 1827 and 1838. The name of Robert Havell Jr. (1793–1878) is inextricably linked with the realization of Audubon's magnum opus. Having trained at his family's engraving studio in Reading, England, Havell used a process that combined engraving, aquatint, etching, and hand-applied watercolor to reproduce Audubon's 435 images, which represent some 500 species. Following its publication, *The Birds of America* came to be valued by nineteenth-century naturalists for its precise anatomical renderings as well as for its depiction of the birds in their natural habitats, as the two plates included in this exhibition demonstrate. Havell's work on the "double elephant folio" plates made it possible for Audubon's images to reach a wider viewership.

Leopold Blaschka
1822, Böhmisch Aicha (Český Dub), Bohemia – 1895, Hosterwitz

Rudolph Blaschka
1857, Hosterwitz – 1939, Hosterwitz

Born in Bohemia in 1822, Leopold Blaschka created his first glass specimens, models of flowers, in 1857—the same year his son Rudolph was born. They began working together in 1876 when Rudolph was 19. Based in the family home outside Dresden, they soon became prolific in their output of intricate flame-worked models, helping to sustain the nineteenth-century enthusiasm for taxonomic classification. Though today perhaps best known for the botanical studies that resulted from a decades-long contract with Harvard University, the Blaschkas also crafted a diverse body of marine invertebrates like the medusas, or jellyfish, included in this exhibition. Initially based on scientific illustrations, such models were later inspired by observations of actual specimens. The ephemerality of the subjects is echoed in the fragility of the glass objects, which today are found predominantly in the collections of natural history museums.

James Castle
1899, Garden Valley, Idaho – 1977, Boise, Idaho

The conditions of James Castle's birth made it unlikely that he would become an artist. Castle was born deaf in 1899 into a large family in rural Garden Valley, Idaho, where his parents operated a general store and post office. He never learned to speak or read, nor was he trained as an artist, and yet the formal language he came to develop was distinctive and sophisticated. Castle's preferred subjects were the places, people, and objects he knew from life: farmyard scenes, domestic interiors, and animals, like the birds included in this exhibition, which he often depicted in the unique medium of soot and saliva on paper. He also made found-paper constructions, stitched together with string and often darkened with soot, which assert a more sculptural presence. Castle likely acquired bits of found paper and cardboard initially from his mother's mailroom; later sources included bulk mailing and advertising materials. While highly acclaimed today, these works, never exhibited during Castle's lifetime, gained attention in the contemporary art world only in the later 1990s.

Salvador Dalí
1904, Figueres, Spain – 1989, Figueres

Salvador Dalí came to be associated with Surrealism in the late 1920s. After being expelled in 1926 from the Real Academia de Bellas Artes de San Fernando in Madrid, he relocated to Paris where he developed his paranoiac-critical method, marrying Surrealist ideas with Freudian theory. The *Aphrodisiac Telephone* employs the characteristic Surrealist strategy of juxtaposing common household objects to yield novel associations. The lobster in particular held erotic connotations for Dalí; by aligning the lobster's tail, the location of its sexual organs, with the mouthpiece of the telephone, he draws attention to the mouth as an erogenous zone and the act of eating as potentially, and potently, sexual. The monochrome white version is derived from a 1936 original that combined a black telephone set with a red plaster lobster. Six such reproductions were commissioned for the home of Edward James, a noted British collector of Surrealist work, in 1936.

Mary Delany
1700, Coulston, Wiltshire – 1788, London

Born into a modestly well-off branch of an aristocratic British family, Mary Delany (née Granville) only began to make her cut paper floral designs after she was widowed for the second time. At the age of seventy-two, this well-educated, sophisticated woman devised a novel method of coloring, cutting, and collaging to create what she termed "paper mosaicks," detailed studies of individual plants both local and exotic. Profiting from her close friendship with the Duchess of Portland, Joseph Banks, and others in a loose network of individuals fascinated by the then rapidly expanding science of botany, Delany created some 995 individual studies before failing eyesight forced her to stop working. Long housed in the Department of Prints and Drawings at the British Museum in London, these delicate art works created by a gifted amateur have only recently become the subject of widespread critical and public interest.

Ruth Francken
1924, Prague – 2006, Paris

Although Ruth Francken received her earliest professional training as a painter, at Arthur Segal's school in Oxford (1939–40) and subsequently at the Art Students League in New York (1941), she spent several years designing textiles in the United States. Returning to Europe in 1950, she finally settled in Paris in 1952, where she began producing abstract paintings in the vein of Art Informel. In the mid-1960s she turned to sculpture. *Four and Seven* (1969), in this exhibition, evokes both an alarm clock and a bomb, thus oscillating between the commonplace and the threatening. Symbols were important for Francken: the motif of the telephone represented, for her, a lack of human communication in contemporary life, while the image of scissors, another favorite motif, alluded to the isolation, or "cutting off," of the spiritual world. French theorist Jean-François Lyotard wrote an essay about her work, *L'Histoire de Ruth* ("The Story of Ruth"), in 1983.

Maria Sibylla Merian
1647, Frankfurt am Main – 1717, Amsterdam

Maria Sibylla Merian made invaluable contributions to the conventions of zoological illustration and also to the field of entomology. The daughter of a renowned engraver of scientific illustrations, who died when she was young, Merian was taught to draw by her stepfather, a still-life painter. Her earliest works, dating to her adolescence, were of flowers and caterpillars, the latter based on her garden observations of their metamorphosis into butterflies. Merian lived an unconventional life. After divorcing her husband of twenty years, she joined a religious community in Friesland and then moved to Amsterdam. In 1699 she travelled to Suriname with one of her daughters to research and document plants and insects, as well as the ways in which native peoples used these as sources of food and medicine. Merian's illustrations from the trip, published as *Metamorphosis Insectorum Surinamensium* in 1705, brought her success and renown. Attesting to the artist's life-long fascination with the caterpillar, the watercolors included in this exhibition often served as preparatory studies for her illustrated publications.

Manuel Montalvo
1937, San Sebastian, Spain – 2009, Madrid

After studying at the humanistic Cité Internationale in Paris and winning notable prizes for his painting in the early 1960s, Manuel Montalvo effectively abandoned an artistic career and began to design for the commercial ceramics industry. Only toward the end of his life did Montalvo return to art-making, primarily in the form of drawings, which he compiled in intimate, handmade books, their pages crowded with tiny illustrations arranged typologically by subject—insects, fish, crockery, fashion, toys, heraldic emblems, even saints. At times the illustrations are colored, as in the brilliant pages of birds; in other instances, simple line drawings in black ink sufficed. Montalvo also added dense, miniature lists, maps, and charts to his books, interspersing pages of such data among pages with images, patterns, and purely abstract designs. Increasingly reclusive, the artist devoted the final decade of his life to the production of some twenty of these encyclopedic volumes.

José Celestino Mutis
1732, Cadiz, Spain – 1808, Bogotá, Colombia

As a young man José Celestino Mutis earned a medical degree at Seville before pursuing studies in botany and mathematics while teaching anatomy at the University of Madrid. Botany was to prove his enduring passion. In 1760 he left Spain permanently as private physician to the new viceroy bound for New Granada (today an area largely coinciding with Colombia). There Mutis eventually established a botanical mission, which explored an area of some 8,000 square kilometers, in a range of climates. Under his supervision, some 6,700 botanical specimens were discovered, collected, and recorded through precisely detailed drawings. Following his death, his extensive natural history collection and the botanical specimens were sent to Madrid, where they languished in obscurity, in the collection of the Archivio Real Jardín Botánico, for over a century. Since the drawings were not published in his lifetime, Mutis never gained the recognition in scientific circles that his discoveries warranted. By contrast, his renown as a promoter of scientific research, established both through professional friendships, such as that with the eminent Swedish botanist Linnaeus, and his pioneering fieldwork, has long been secure.

Judith Scott
1943, Columbus, Ohio – 2005, Dutch Flat, California

Institutionalized for decades because of Down syndrome, Judith Scott embarked on her first artistic ventures in middle age, after her twin sister moved her to California and enrolled her in the Creative Growth Art Center in Oakland, a facility for individuals with disabilities. It was there that Scott, who was deaf and mute, slowly developed her distinctive process of wrapping found objects with densely woven layers of string, cloth, or yarn. Many of the resulting sculptures, including several of those in this exhibition, have been likened to cocoons. Each work takes its unique shape from an object or objects at its core; the forms of such objects are simultaneously obscured and yet accentuated by layer after fibrous layer. Scott's keen, intuitive sense of color and texture, along with her singular technique, has led to rapidly growing interest in her work in recent years, beyond the sphere of outsider art in which it was first noticed.

Wladyslaw Starewicz
1882, Moscow – 1965, Fontenay-sous-Bois, France

Born in Moscow to Polish parents, Wladyslaw Starewicz made short documentaries before he inadvertently learned of the stop-motion technique when he tried to film mating stag beetles and found them difficult to control. At some point between 1910 and 1912, he began to produce short narrative films, using stop-motion to animate puppets inside his handmade sets. Using the carcasses of actual beetles, the second of these short films, *The Cameraman's Revenge*, reveals his witty, inventive, almost surreal manner through a fantastical account of romantic scheming and betrayal among insects. As a young man, Starewicz had studied entomology as well as drawing, two fascinations that came together supremely in *The Cameraman's Revenge*—undoubtedly the filmmaker's first great work and a foundational contribution to the genre of animation. After the 1919 revolution, Starewicz left Russia for Paris, where he would spend the rest of his life creating his signature animations based on Aesop's fables and folktales from Eastern Europe and beyond.

Günter Weseler
1930, Olsztyn, Germany [now Poland]

German artist Günter Weseler studied architecture at the Braunschweig Institute of Technology before turning to sculpture. In the mid-1960s he made the first of his "breathing objects," a pair of which is included in this exhibition. Comprised mostly of fake fur wrapped around small motors, the *Atemobjekte* often cling to walls, or burrow into rugs, or nestle in birdcages. As they gently expand and contract, they seem to quiver with life. Weseler has spoken of his interest in bringing a sense of vitality to the sculptural object, a process of animation that he has connected to the marvels of life-sustaining pharmaceuticals or pacemakers. This exhibition includes a work that speaks of a more primitive form of animation: *Objekt für Atemtraining*, comprised of a deflated balloon encircled by a strip of fur, invites viewers to literally breathe life into it. Weseler collaborated with Rosemarie Trockel to create *Fly Me to the Moon*, 2011, specifically for this project.

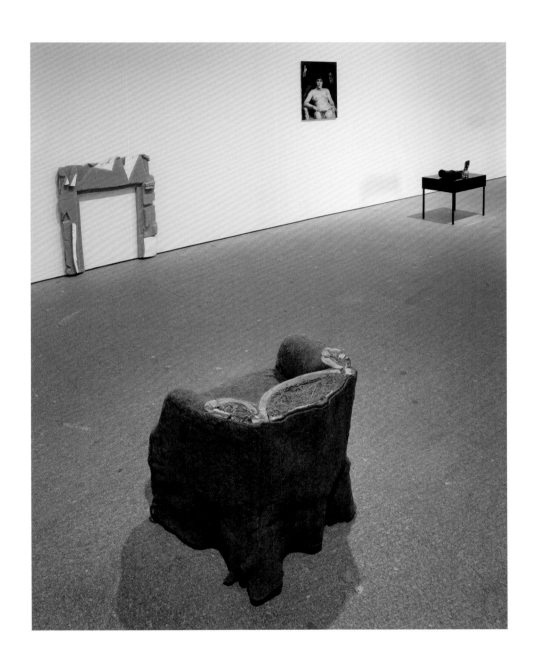

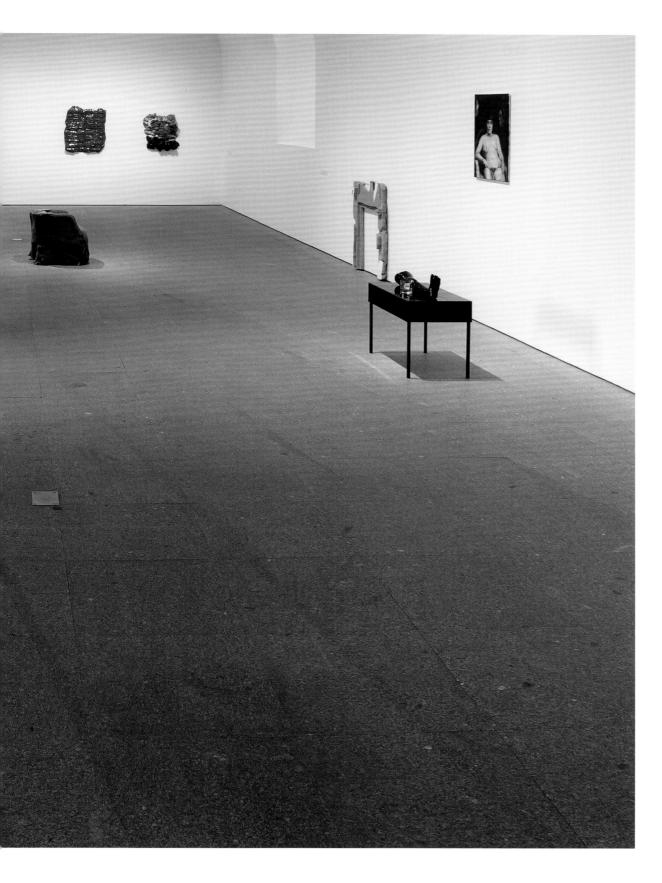

51

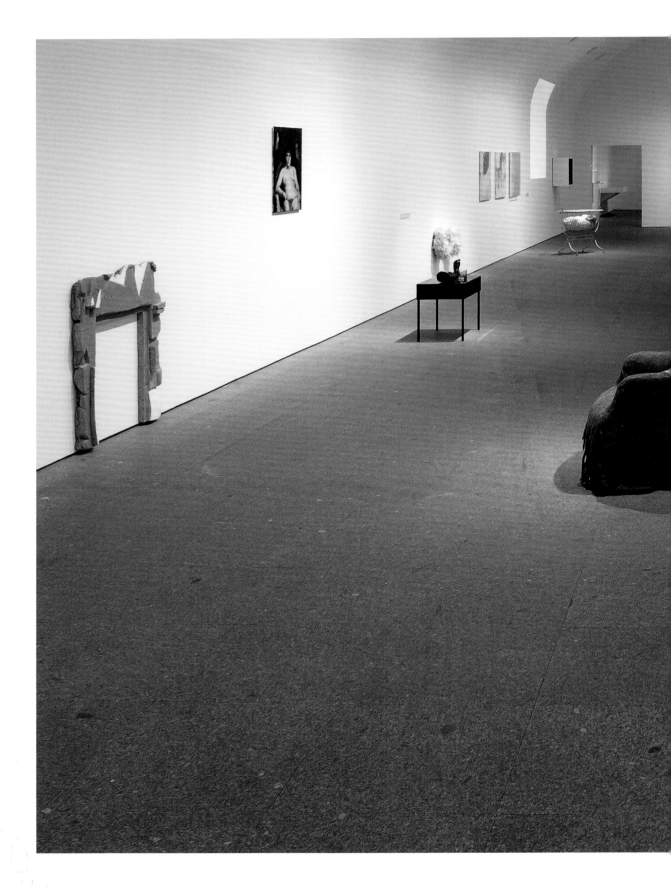

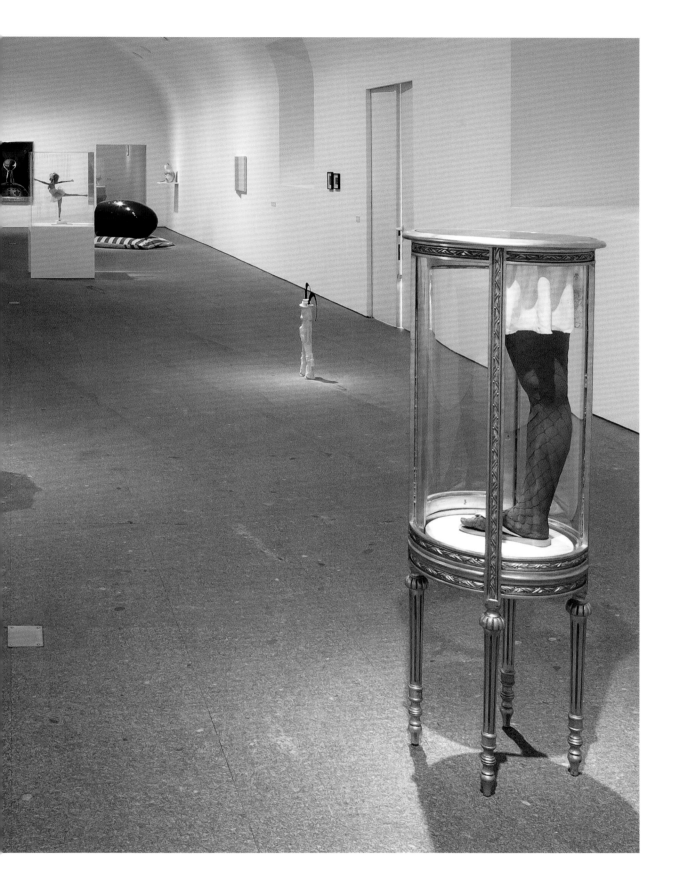

53

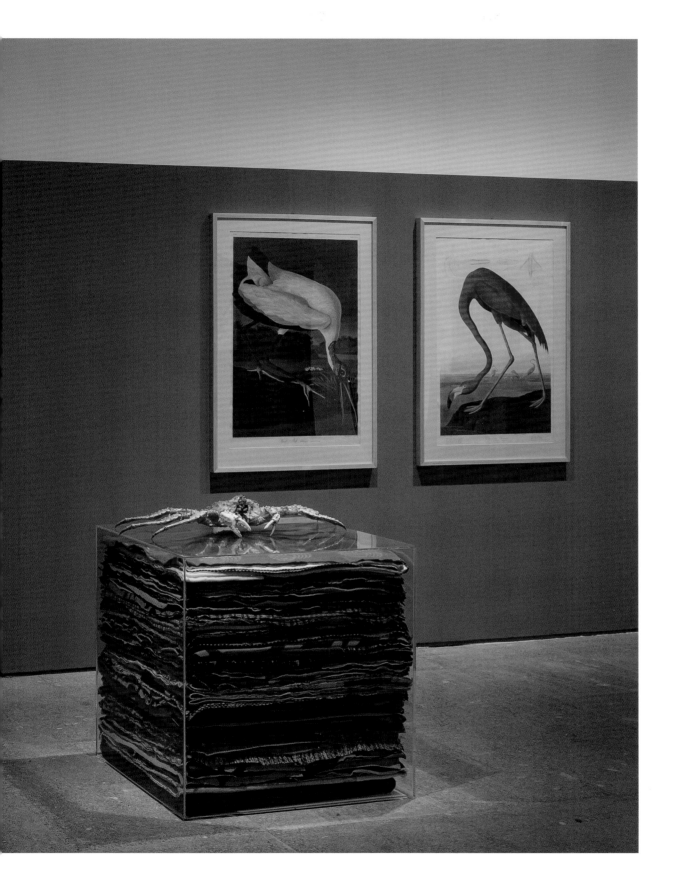

56

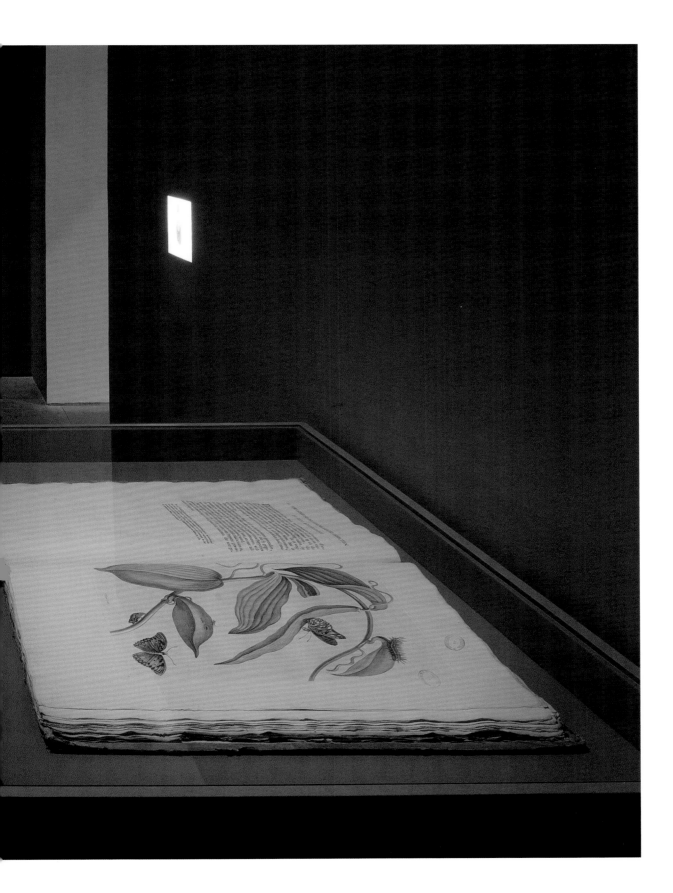

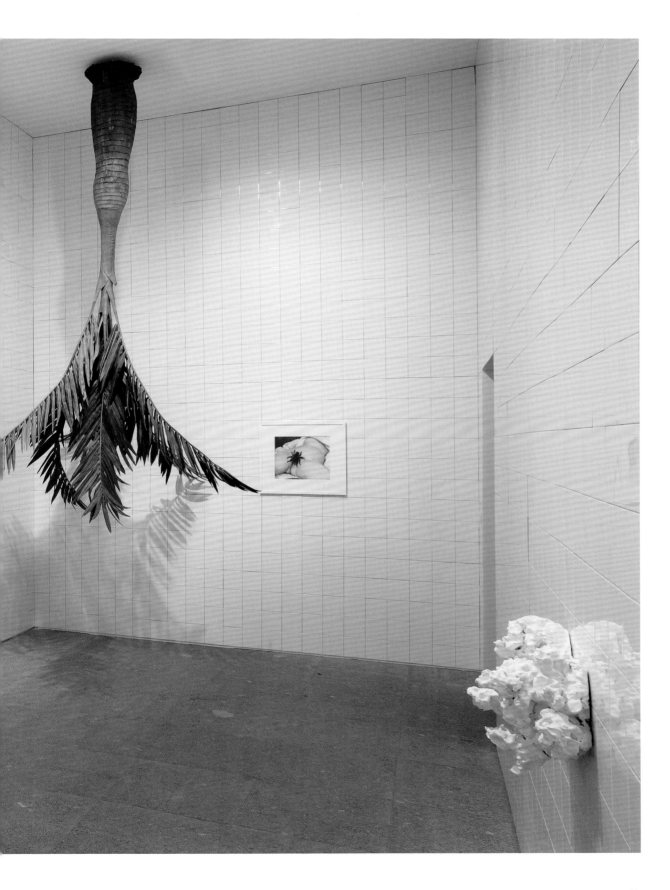

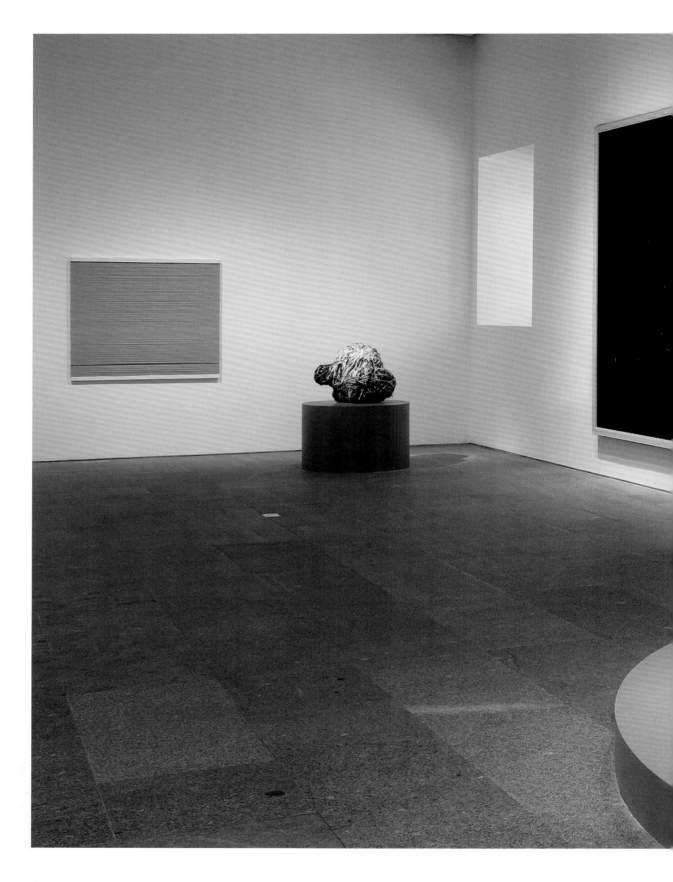

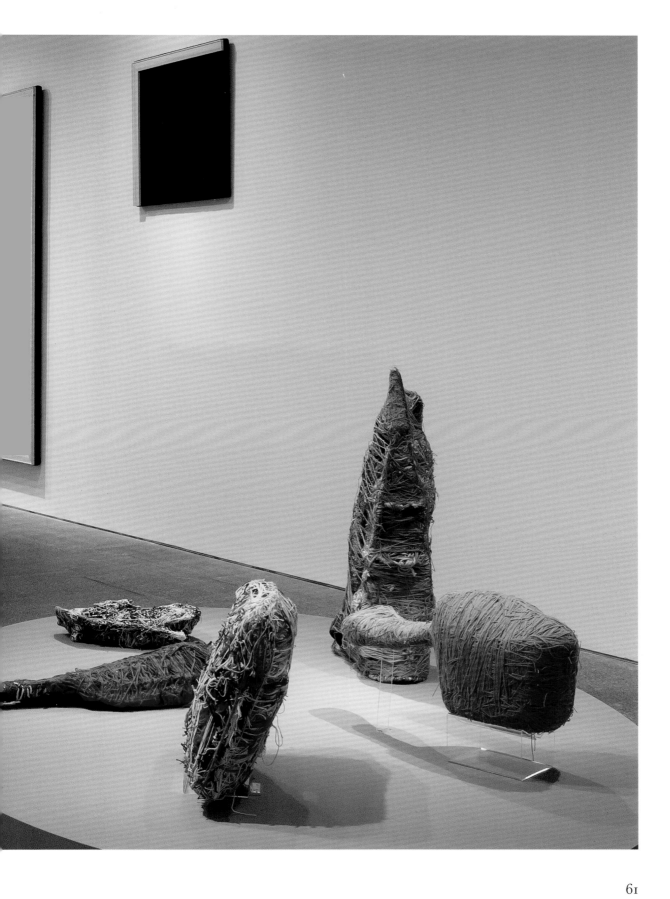

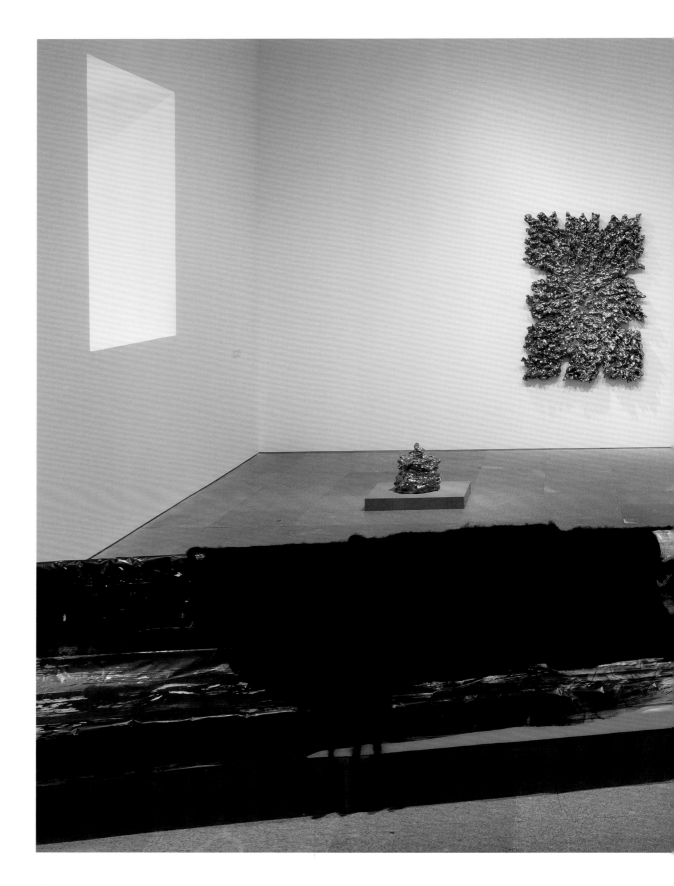

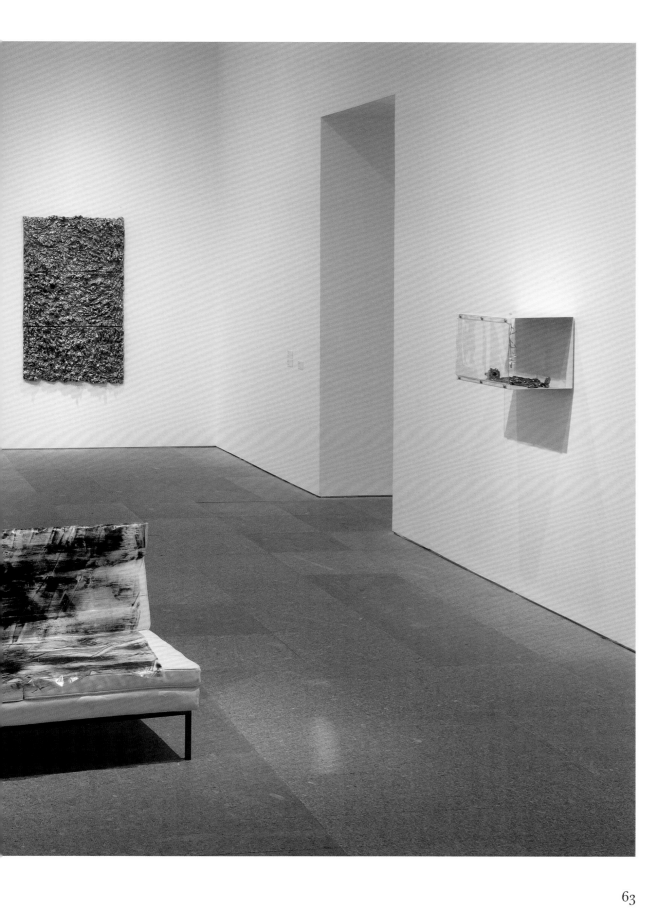

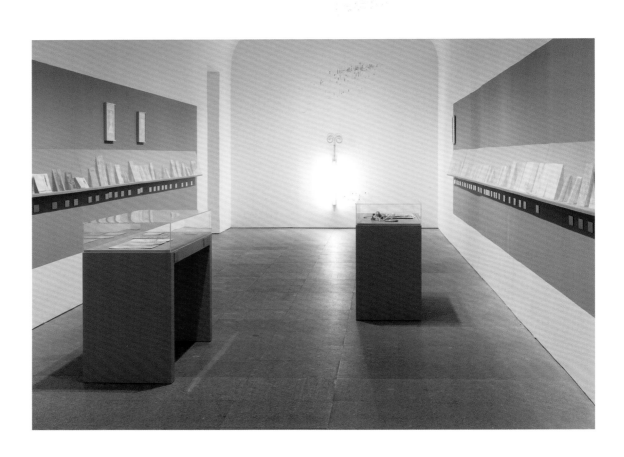

CHAPTER I.

botany

Rosemarie Trockel
José Celestino Mutis
Mary Delany
Maria Sibylla Merian

ROSEMARIE TROCKEL

Paws Down, 2011
Digital print on cardboard
20.5 x 25.5 cm

ROSEMARIE TROCKEL

Prima-Age, 2012
Digital print on cardboard
42 x 42 cm

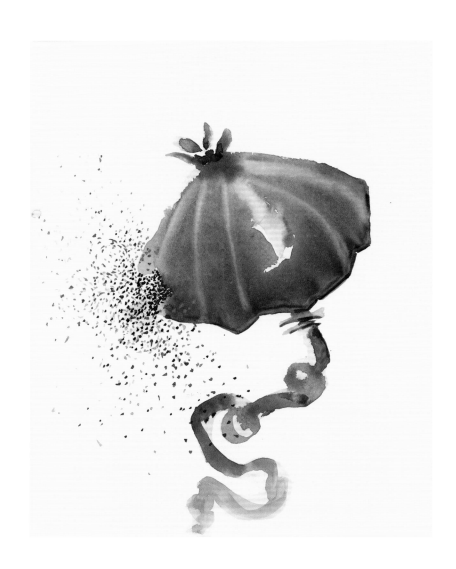

ROSEMARIE TROCKEL

Mechanical Reproduction, 1995
Acrylic on paper
20.5 x 25.5 cm

ROSEMARIE TROCKEL

Mechanical Reproduction, 1995
Pencil on paper
26 x 27.8 cm

JOSÉ CELESTINO MUTIS
Director, Royal Botanical Expedition to
New Granada (1783–1816)

ANONYMOUS

Aristolochia sp. (Aristolochiaceae), n.d.
Tempera on paper
54.6 x 38 cm

Aristolochia cordiflora Mutis ex Kunth (Aristolochiaceae), n.d.
Ink on paper
54.6 x 38 cm

Aristolochia sp. (Aristolochiaceae), n.d.
Tempera on paper
54.6 x 38 cm

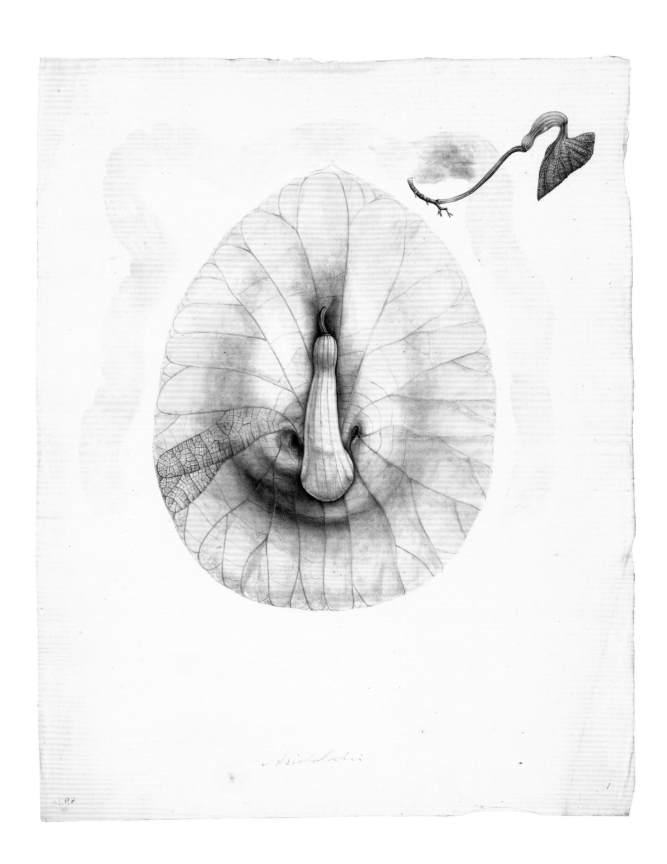

Aristolochia

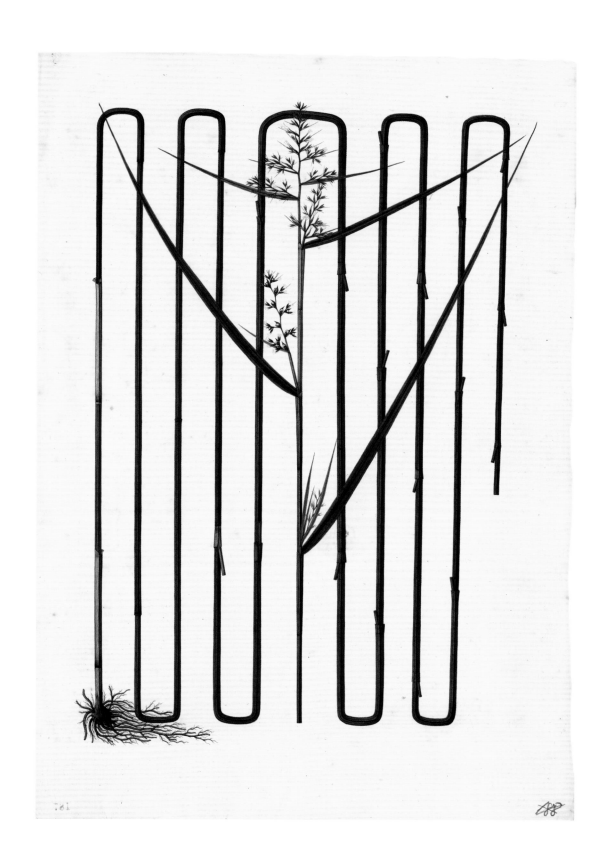

JOSÉ CELESTINO MUTIS
Director, Royal Botanical Expedition to
New Granada (1783–1816)

ANONYMOUS

Scleria secans Urb. (Cyperaceae), n.d.
Tempera on paper
54.6 x 38 cm

Kyllinga pumila Michx. (Cyperaceae), n.d.
Tempera on paper
54.6 x 38 cm

Francisco Javier MATIS MAHECHA

Plumeria sp. (Apocynaceae), n.d.
Tempera on paper
54.6 x 38 cm

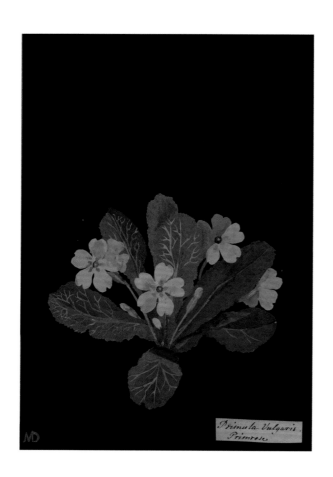

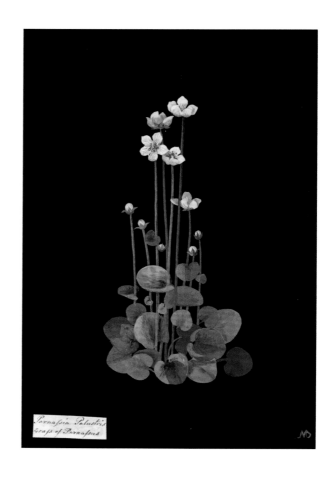

MARY DELANY

Primrose Primula vulgaris acaulis
(Petandria Monogynia), c. 1772–75
Collage of colored papers, with bodycolor and
watercolor, on black ink background
24.3 x 17.3 cm

Grass of Parnassus Parnassia palustris
(Pentandria Tetragynia), c. 1776
Collage of colored papers, with bodycolor and
watercolor, and a leaf sample, on black ink background
31;3 x 22.6 cm

Climbing fumitory Fumaria fungosa
(Diadelphia Hexandria), 1776
Collage of colored papers, with bodycolor and
watercolor, on black ink background
26.8 x 21 cm

76

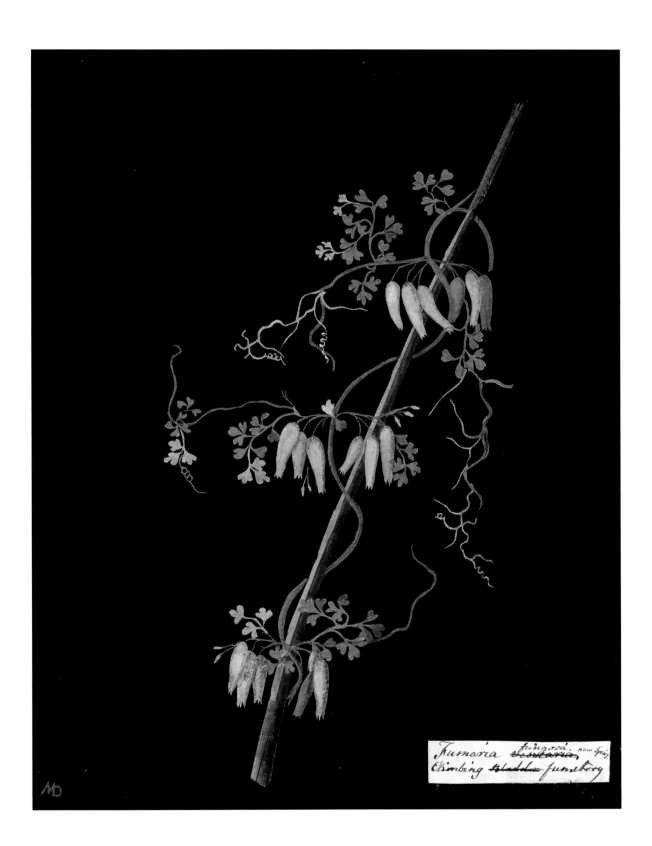

Fumaria fungosa. new Spec.
Climbing Bladder Fumetory

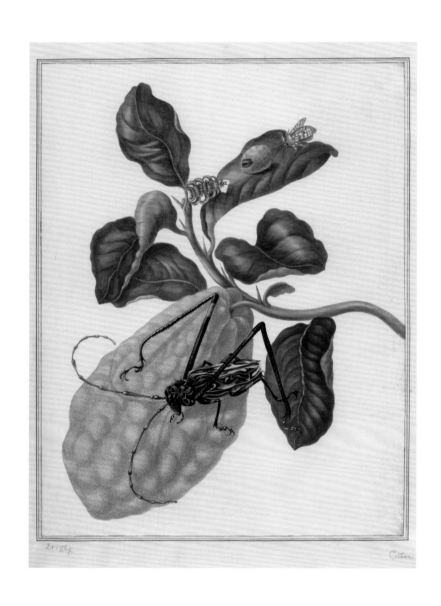

MARIA SIBYLLA MERIAN

Citron with a Moth and a Harlequin Beetle, c. 1701–2
Watercolor and bodycolor over pencil and
etching on vellum
36.1 x 27.8 cm

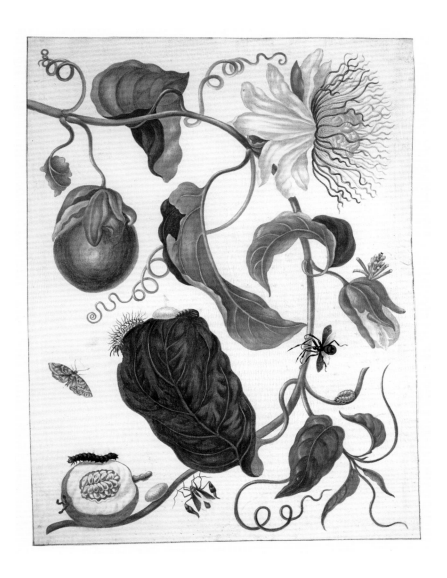

MARIA SIBYLLA MERIAN

Flower Plant and Flag-legged Bug, c. 1701–5
Watercolor and bodycolor over lightly etched
outlines on vellum
38 x 28.8 cm

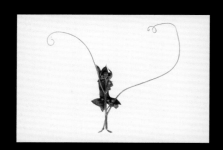

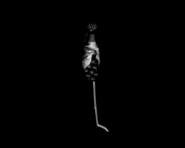

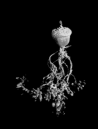

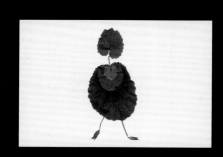

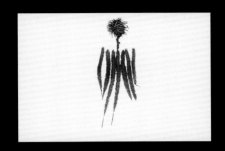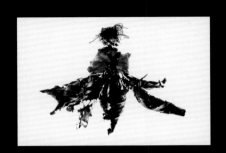

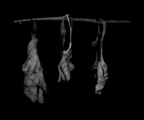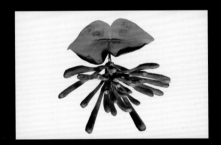

ROSEMARIE TROCKEL

Park Avenue, 2006/2011
23 35-mm color slides

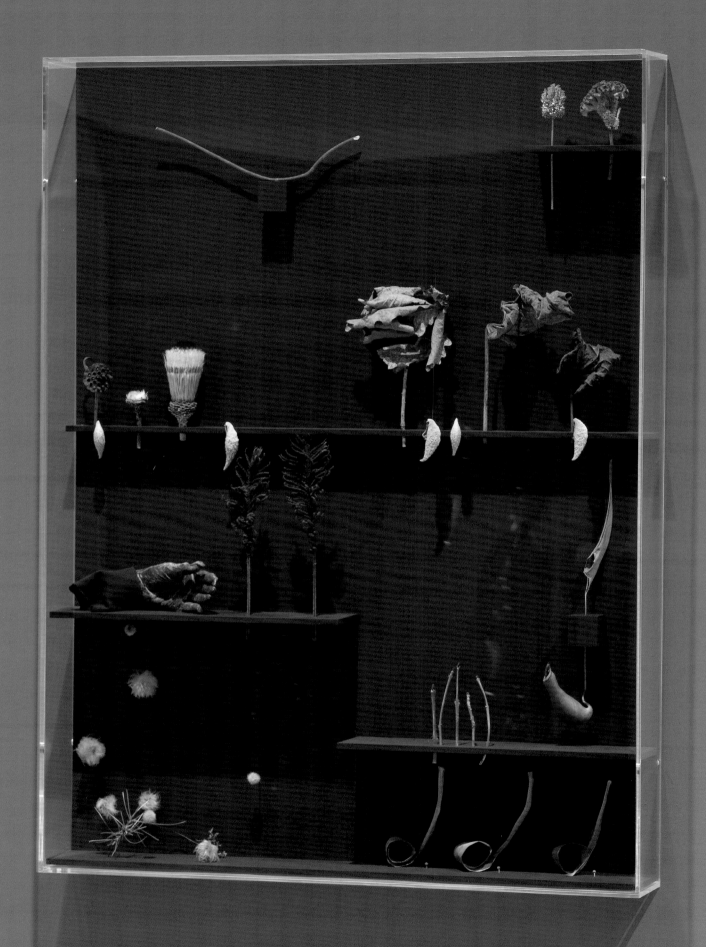

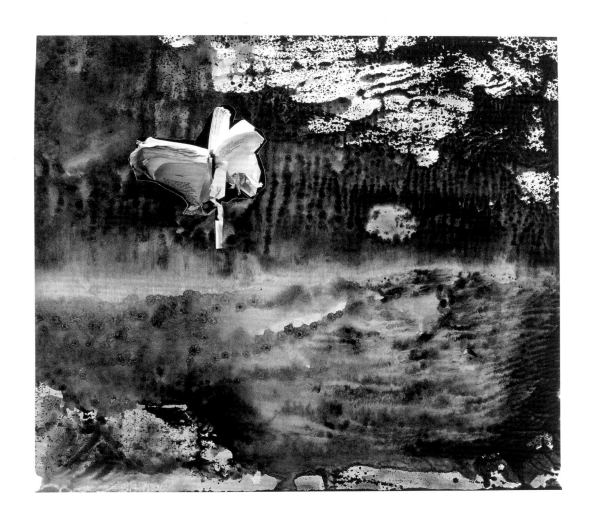

ROSEMARIE TROCKEL

Picnic, 2012
Mixed mediums
150 x 100 x 16 cm

Departure, 2010
Acrylic, graphite, and paper on paper
39 x 44.5 cm

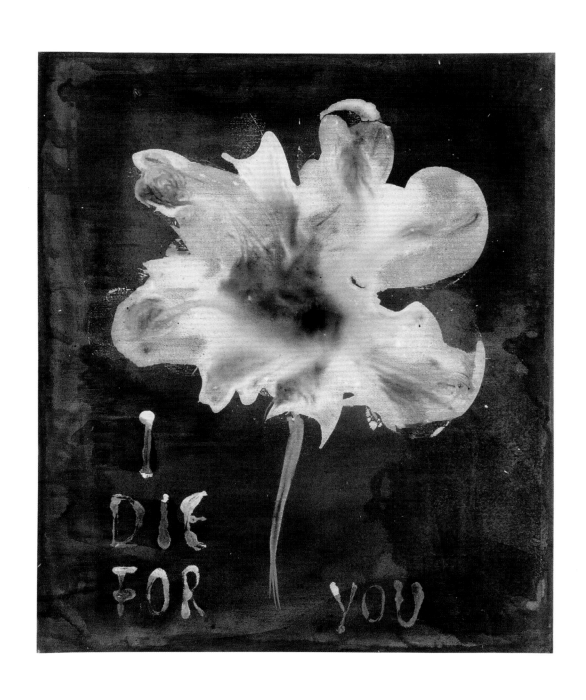

ROSEMARIE TROCKEL

Florence, 2010
Acrylic and graphite on paper
56.5 x 49.5 cm

84

CHAPTER II.

zoölogy

Rosemarie Trockel

Maria Sibylla Merian

Leopold and Rudolph Blaschka

John James Audubon / Robert Havell

James Castle

Wladyslaw Starewicz

Morton Bartlett

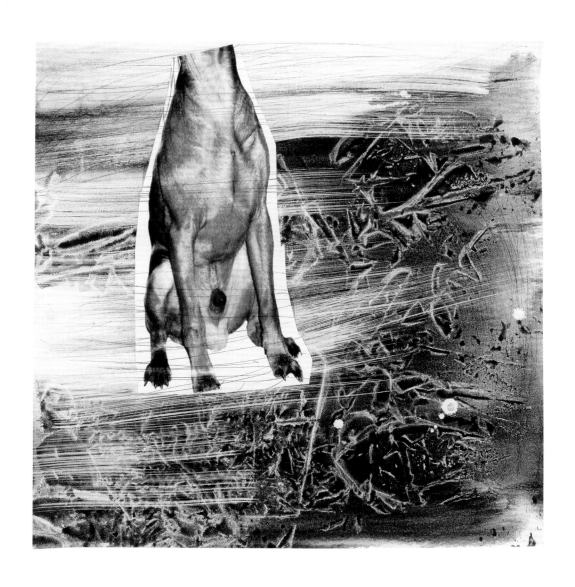

ROSEMARIE TROCKEL

Candleholder, 2010
Graphite, acrylic and silkscreen print on canvas
48.9 x 48 cm

DE XXV. AFBEELDING.

Dit is de grootfte zoort van *Ranille*, twee zoorten waffen op Surinaame, d'andere zoort is wat kleinder van blad en vrucht, de bladen zyn dik als een vinger, ruim zo dik als in Europa den Huis-look, deze klimd de boomen op als de Klim, en maakt fig heel vaft aan de zelve, haar fteel en blad is gras groen, de groene vrucht is als een boon driehoekig, vol van welriekende olyachtige zaden, fy waft in 't wild aan de hoogfte boomen, doch lieft aan zulke boomen, die in vogtige en moeraffige plaatzen ftaan, haar gebruik in de Chocolade is bekend, het is jammer dat geen curieufe menfchen in dat land zyn, die zulke dingen cultiveren, en meer andere opzoeken, die zonder twyfel in dat groote en vruchtbare land zoude te vinden zyn.

Deze bruine Rupfen met geele ftreepen heb ik veel op deze planten gevonden, (gelyk ook op de Muracuja of Paffie bloem onder No. 16. te zien is) die fy gegeten hebben tot aan het einde van May, wanneer fy fig vaft gemakt en tot Popperjes geworden zyn, daar uit den 7. Juny zodanige fchoone Capellen voortkwamen, welkers binnenfte zyde zaffraan geel, en hare buitenfte geel, rood, bruin, en met zilvere vlekken verziert was, gelyk alhier zittend en vliegend vertoond word.

Nog vind fig op deze plant een klein Rupsken als op het onderfte blad te zien is, groen van verf, den 12. February 1700. is fy my tot een groen Poppetje geworden, waar uit des daags een klein graauw Uilke voortkwam, dat zeer gefwind in 't vliegen was.

Dit is de Vohihilis filiquofa mexicana foliis plantaginis van Rajus, den Viluochid, five niger & mauis aromaticus van Hernandes in zyn Hifteria mexicana, en is de Vanilla flore viridi & albo, fructu nigrefcente van Plumier, in zyn traftaat no- | *va plantarum Americanarum genera: met noch veel andere benamingen werd die geruat van verfcheide Autevren vvorgefteld, die alle te vinden zyn in het Almagtftum botanicum van Plukenet pag. 381.*

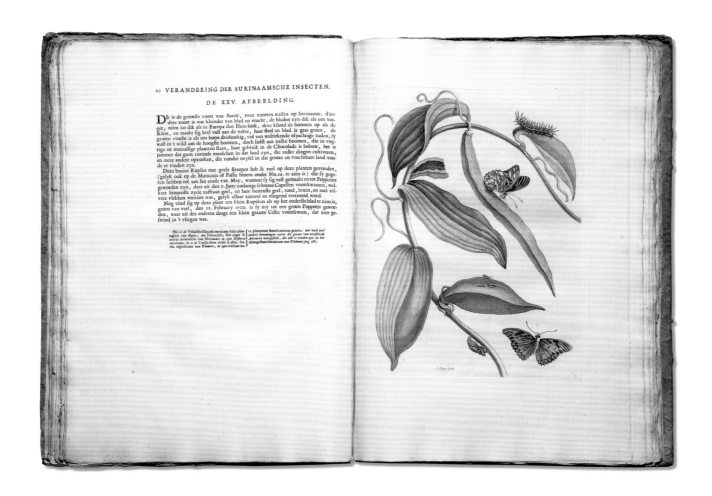

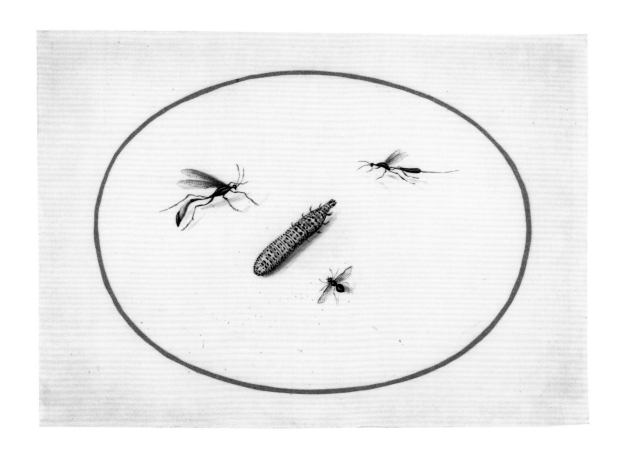

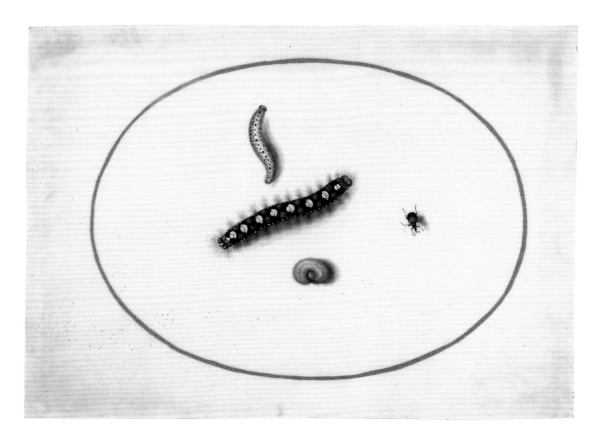

88

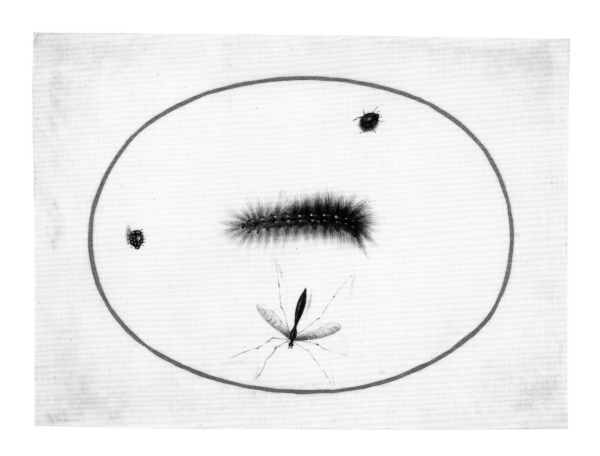

MARIA SIBYLLA MERIAN

Caterpillar and Three Termites made in Fine Miniature,
inside a Golden Ellipse, before 1660
Tempera on parchment
12.1 x 16.5 cm

Three Caterpillars and a Small Beetle Made in Fine Miniature,
inside a Golden Ellipse, before 1660
Tempera on parchment
14.4 x 19.5 cm

Caterpillar and Other Small Insects Made in Fine Miniature,
inside a Golden Ellipse, before 1660
Tempera on parchment
12.1 x 16.5 cm

LEOPOLD and RUDOLPH BLASCHKA

Jellyfish Polyenia alderii, c. 1863–1890
Glass
21 x 6.5 x 6.5 cm

Jellyfish Porpita mediterranea *(Porpitidae)*, c. 1863–1890
Glass
21 x 8 x 8 cm

Golf tee medusa Aegina citrea *(Aeginidae)*, c. 1863–1890
Glass
22 x 8.5 x 8.5 cm

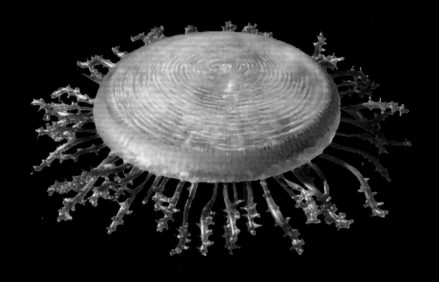

92

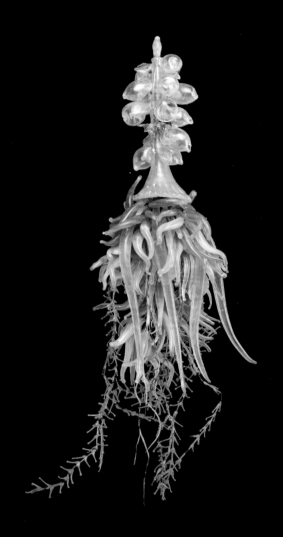

LEOPOLD and RUDOLPH BLASCHKA

Moon jellyfish Aurelia aurita *(Ulmaridae)*, c. 1876
Glass
9 x 6 x 21 cm

Jellyfish Polyclonia frondosa, c. 1876
Glass
9 x 6 x 21 cm

Siphonophore Physophora myzonema *(Physophoridae)*, c. 1876
Glass
9 x 6 x 21 cm

N° 44 PLATE CCXVI

Wood Ibis TANTALUS LOCULATOR.

After JOHN JAMES AUDUBON
by ROBERT HAVELL

Wood stork Mycteria americana *(Ciconiidae)*, 1834
Etching and aquatint on paper
84.5 x 61.4 cm

After JOHN JAMES AUDUBON
by ROBERT HAVELL

American flamingo Phoenicopterus ruber *(Phoenicopteridae)*, 1838
Etching and aquatint on paper
84.5 x 61.4 cm

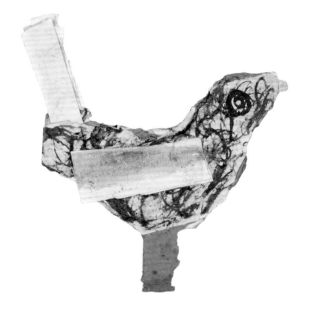

JAMES CASTLE

Untitled (CAS10-0313), n.d.
Found paper, pigment of unknown origin, and wheat paste
14.61 x 15.24 cm

Untitled (CAS11-0260), n.d.
Found paper, soot, pigment of unknown origin, and string
20.32 x 19.69 cm

Untitled (CAS10-0314), n.d.
Found paper, soot, and wheat paste
12.07 x 11.75 cm

Untitled (CAS09-0325), n.d.
Found paper, soot, string, fabric, and hemp
53.34 x 36.83 cm

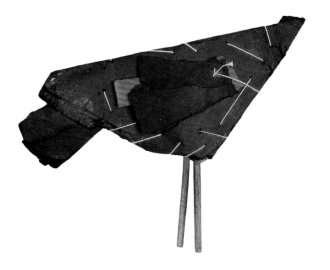

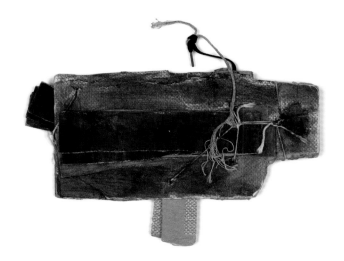

JAMES CASTLE

Untitled (CAS09-0039), n.d.
Found paper, soot, pigment of unknown origin,
graphite, string, and ribbon
48.26 x 36.83 cm

Untitled (CAS09-0042), n.d.
Found paper, string, and wood
12.7 x 18.1 cm

Untitled (CAS11-0264), n.d.
Found paper, soot, pigment of unknown origin,
string, and cord
16.83 x 27.62 cm

Untitled (CAS10-0310), n.d.
Found paper, soot, wheat paste, and string
10.8 x 11.75 cm

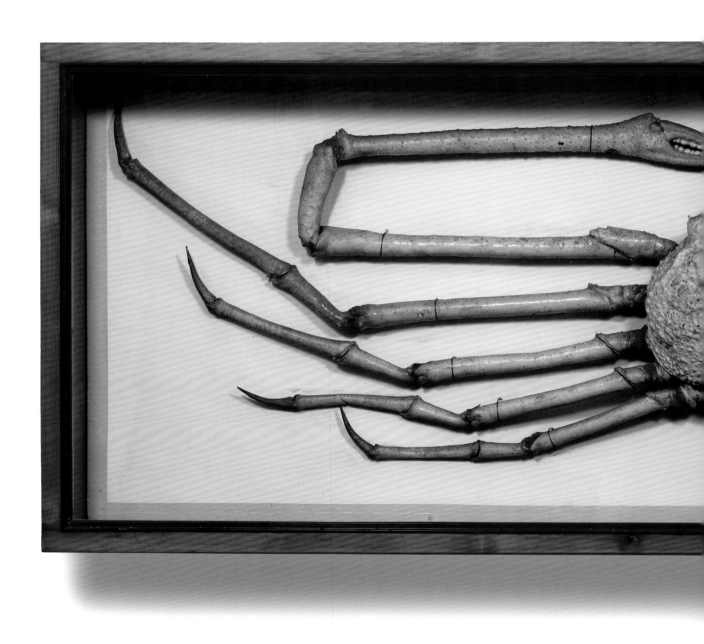

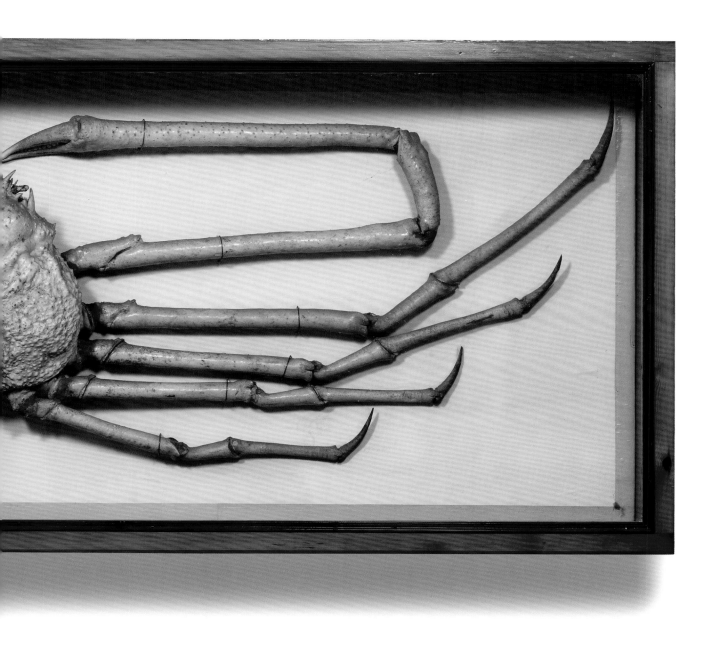

Japanese spider crab Macrocheira kaempferi *(Majidae)*,
mid-19th century
Crab specimen
207 x 77 x 23 cm

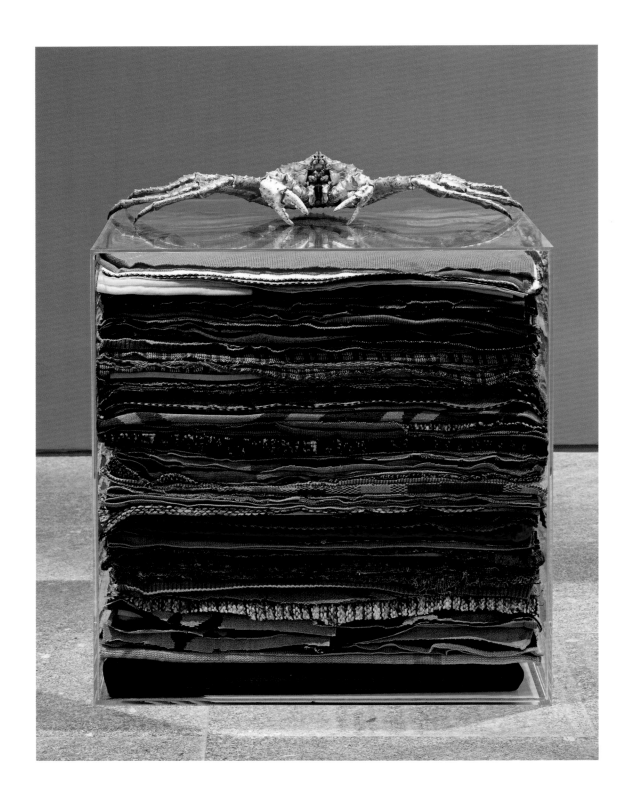

ROSEMARIE TROCKEL

Lucky Devil, 2012
Crab specimen, perspex, textile
90 x 77 x 77 cm

ROSEMARIE TROCKEL

Less Sauvages than Others, 2012
Painting made by the ourangutan Tilda
One of three pieces, each measuring 80 x 80 cm

ROSEMARIE TROCKEL

Less Sauvages than Others, 2012
Painting made by the ourangutan Tilda
One of three pieces, each measuring 80 x 80 cm

ROSEMARIE TROCKEL

Less Sauvages than Others, 2012
Painting made by the ourangutan Tilda, and perspex
One of three pieces, each measuring 80 x 80 cm

ROSEMARIE TROCKEL (pp. 106-7)

As Far as Possible, 2012
Steel, plastic, fabric, mechanical birds, glass, audio, and wood
90 x 190 x 45 cm

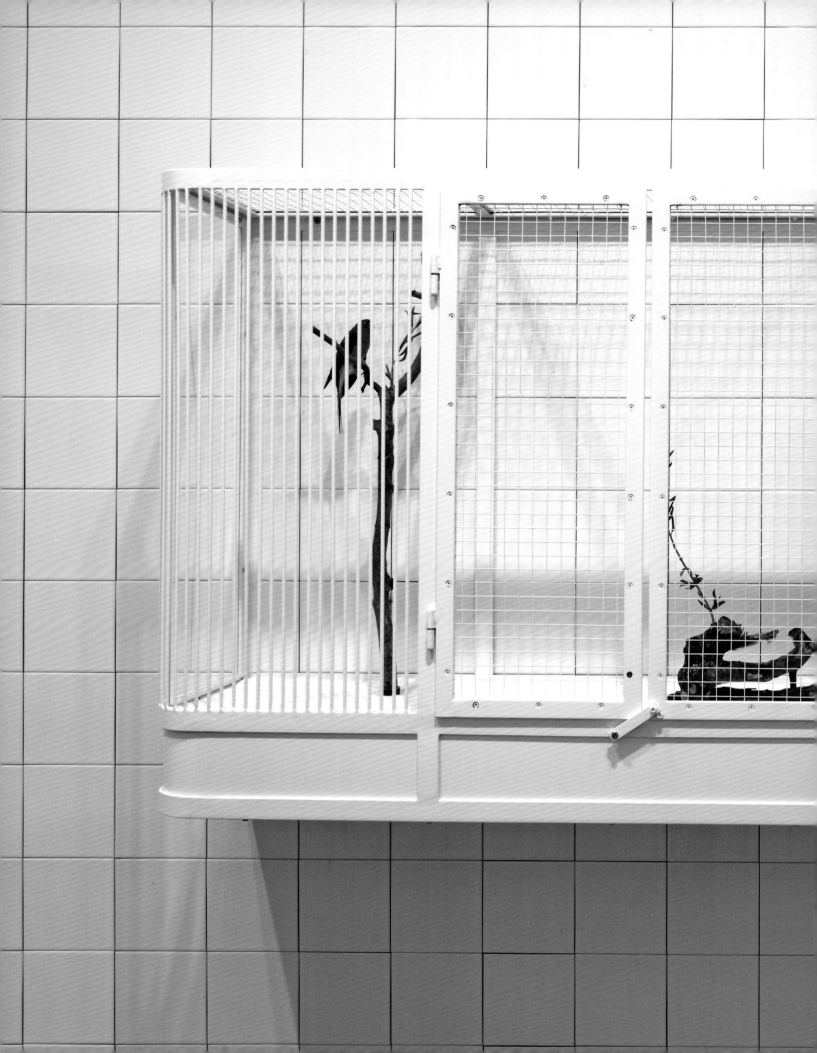

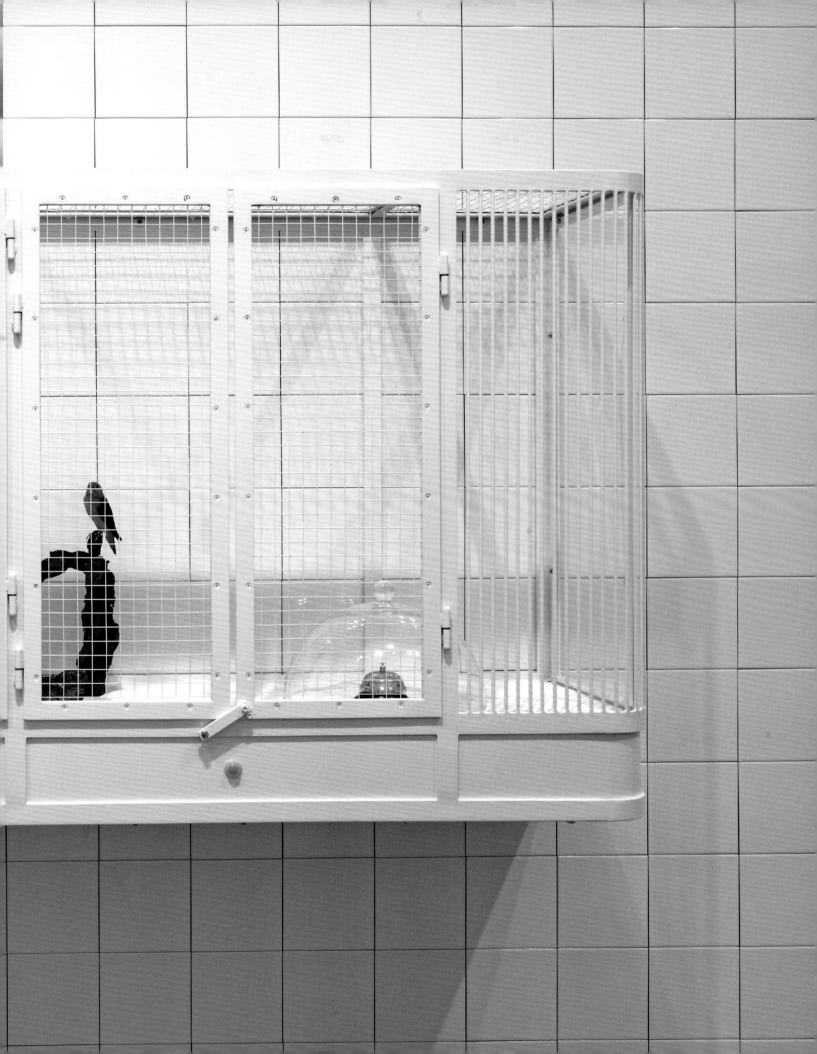

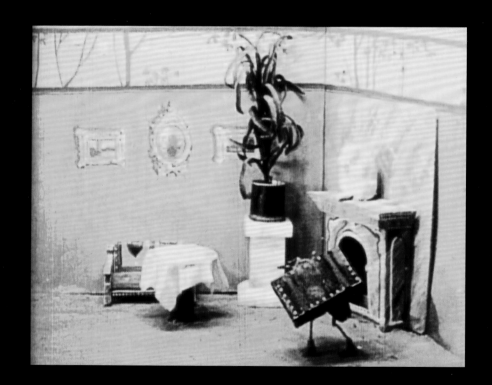

WLADYSLAW STAREWICZ

Stills from *The Cameraman's Revenge,* 1912
35 mm film transferred to video; tinted black-and-white;
sound added later; 13 min

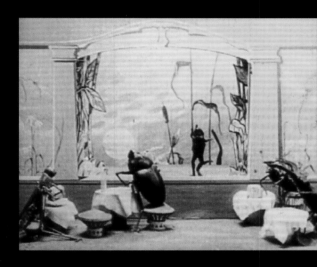

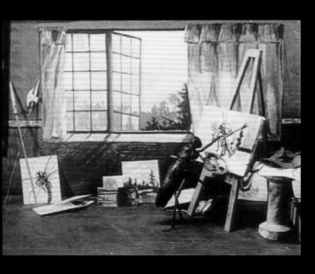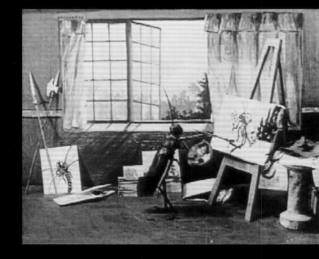

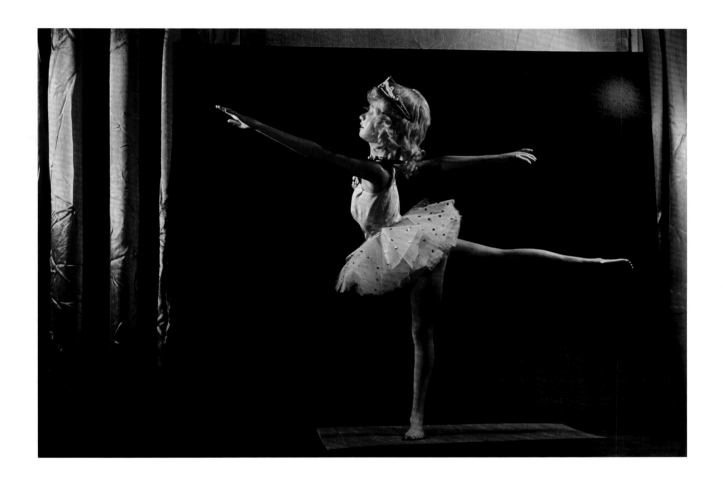

WLADYSLAW STAREWICZ

Stills from *The Cameraman's Revenge,* 1912
35 mm film transferred to video; tinted black-and-white;
sound added later; 13 min

MORTON BARTLETT

Untitled (Ballerina), c. 1955/2006
Chromogenic print on board
51.4 x 71.2 cm

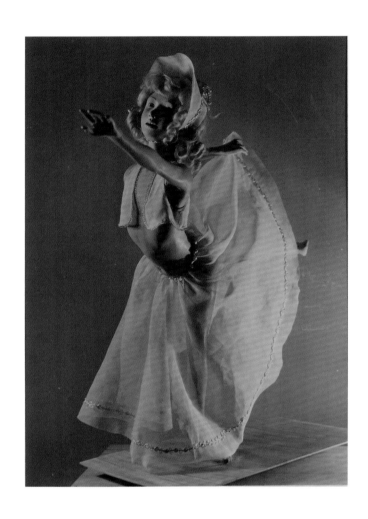

MORTON BARTLETT

Untitled (Ballerina), c. 1950
Black-and-white photograph on paper
12 x 10 cm

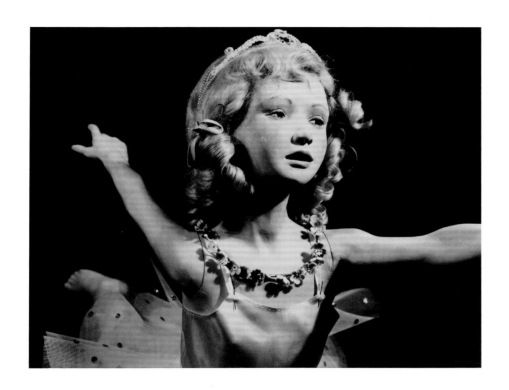

MORTON BARTLETT

Untitled (Ballerina), c. 1950
Black-and-white photograph on paper
10 x 12 cm

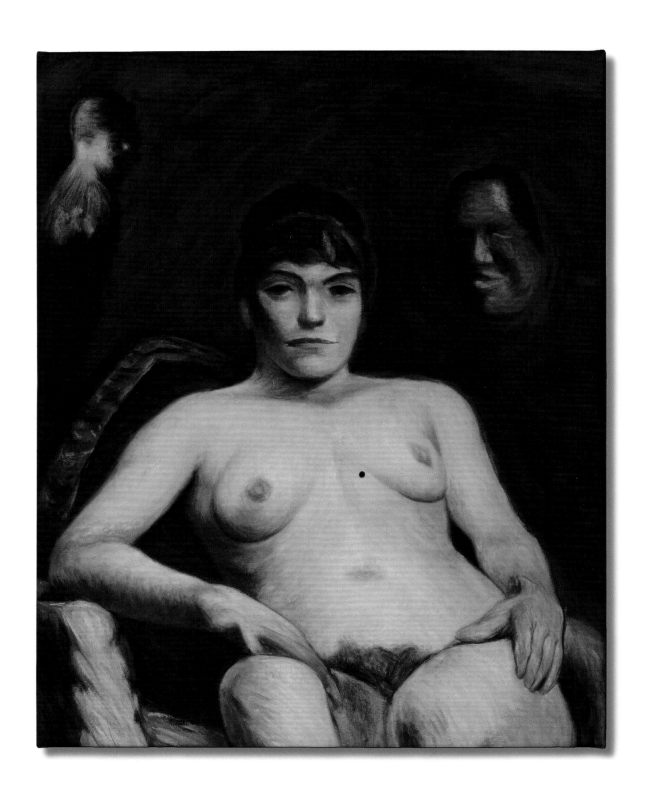

ROSEMARIE TROCKEL

Reborn with Spot, 2011
Oil on canvas
76 x 61 cm

ROSEMARIE TROCKEL

Replace Me, 2011
Digital print on cardboard
60 x 90 cm

ROSEMARIE TROCKEL

Aus Yvonne, 1997
Plastic, wood, paint, polystyrene, and fabric
72.5 x 30 x 30 cm

ROSEMARIE TROCKEL

Stell Dir vor / Imagine (aus Manus Spleen 2), 2002
Silicone, fabric, glass, wood, and plastic
53 x 58 x 29 cm

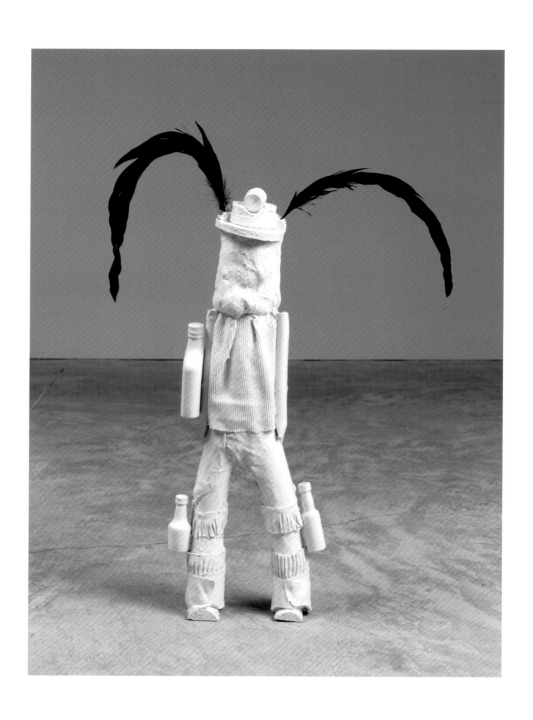

ROSEMARIE TROCKEL

Kiss My Aura, 2008
Metal, feathers, and plaster
65 x 25 x 25 cm

CHAPTER II.

(bis)

Rosemarie Trockel

Günter Weseler

Salvador Dalí

Ruth Francken

ROSEMARIE TROCKEL

Untitled (Alone at Night I Read My Bible More and Euklid Less), 1989
Stencil, ink, silver chain, and cardboard
106.7 x 34.9 x 33 cm

ROSEMARIE TROCKEL

In Raven-Black Nights I Hear Ghosts and See Employees,
1989
Felt pen, cardboard, and box
32.5 x 43 x 5.5 cm

ROSEMARIE TROCKEL

Untitled 3, 1993
Wood and synthetic hair
100 x 100 x 140 cm

GÜNTER WESELER

Atemobjekte New Species U 90 /73 (Nr. 15, Nr. 16), 1973
Synthetic fur and electrical mechanism
20 x 40 cm (diameter) each

GÜNTER WESELER

Objekt für Atemtraining, 1969
Plastic disc, synthetic fur, and balloon
4 x 13 cm (diameter)

ROSEMARIE TROCKEL

Possibilities, 1999
Digital print on metal, perspex, and cardboard
40 x 39 x 1 cm

SALVADOR DALÍ

Aphrodisiac Telephone, 1936
Plastic, plaster, and string
20.96 x 31.12 x 16.51 cm

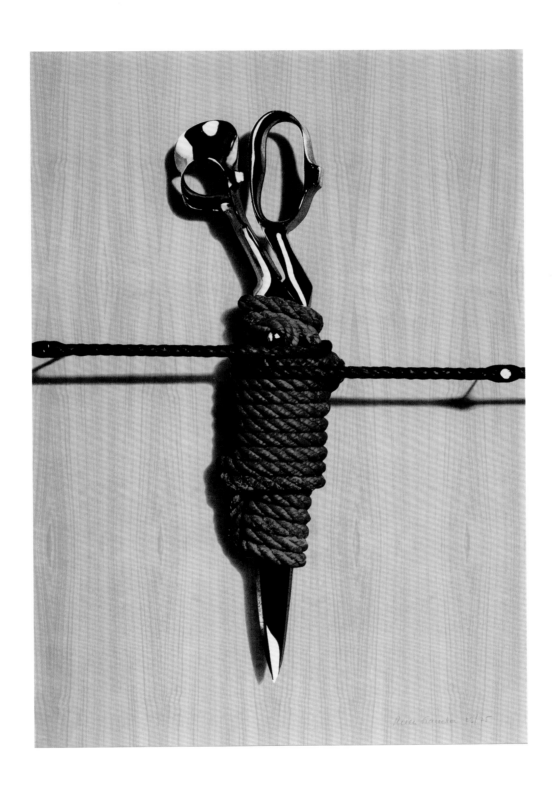

RUTH FRANCKEN

L'anticastrateur, c. 1973
Silkscreen print on paper
86.5 x 61.5 cm

127

RUTH FRANCKEN

Four and Seven, 1969
Aluminum metal numbers, cushion, and other materials
118 x 85 x 85 cm

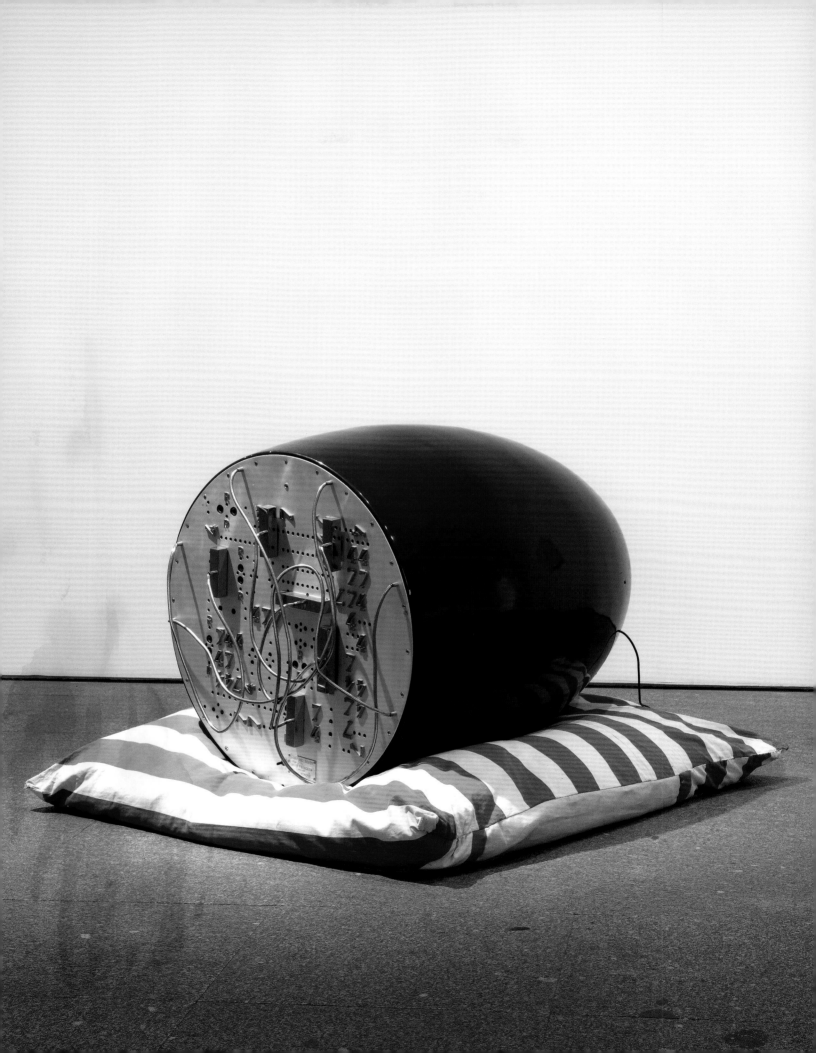

RUTH FRANCKEN

Eros et civilisation, 1972
Monkey fur, metal, black-and-white photograph,
fabric, and perspex
153 x 119 x 6 cm

130

ROSEMARIE TROCKEL

Mosquito Fighter, 2004
Silicone
117 x 26 x 2.3 cm

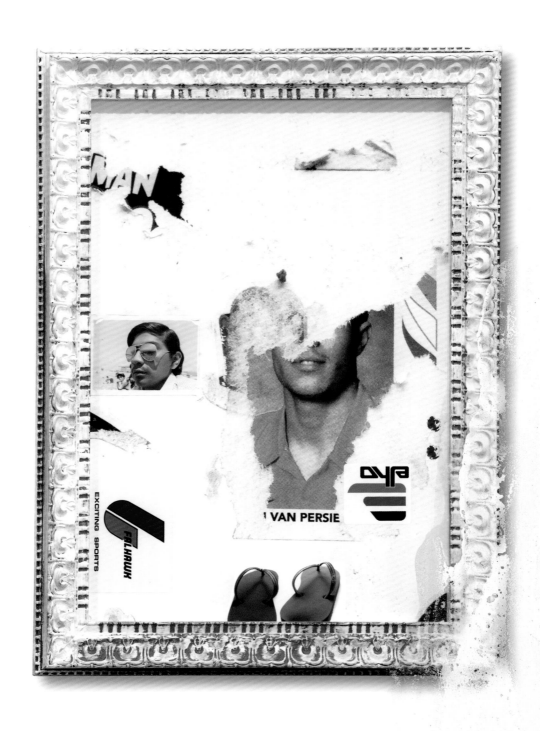

ROSEMARIE TROC L

Retour au vestiaire, 201
Digital print and acr l
85 x 60 cm

132

ROSEMARIE TROCKEL

Retour au vestiaire, 2011
Digital print and acrylic
85 x 60 cm

ROSEMARIE TROCKEL

Question of Time, 2011
Wool and perspex
100 x 130 cm

*Was ein Ding ist, und was es nicht ist, sind
in der Form identisch, gleich*, 2012
Ceramic, wood, glass, rubber, paper, and fabric
152 x 53 cm (diameter)

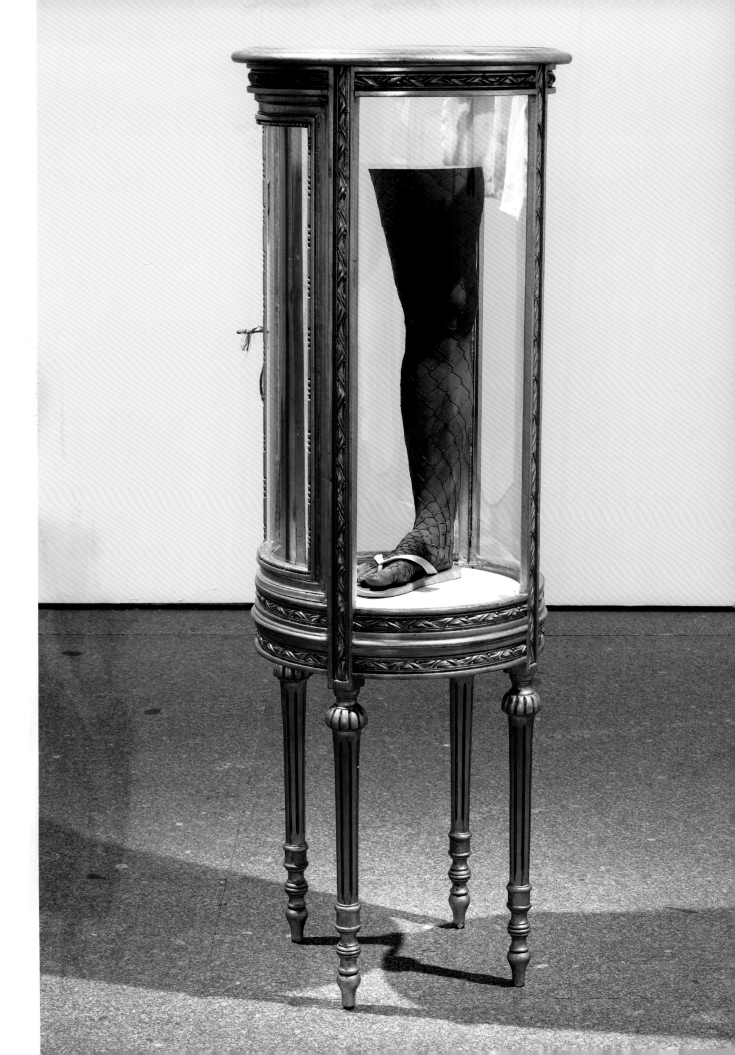

ROSEMARIE TROCKEL in collaboration
with GÜNTER WESELER

Fly Me to the Moon, 2011
Mixed mediums and electrical mechanism
166 x 100 x 55 cm

136

ROSEMARIE TROCKEL

Spiral Betty, 2010
Neon, glass, acrylic, cord, cable, and plug
150 x 35 x 10 cm

Untitled, 1985
Plaster and paint
13 x 20 x 8 cm

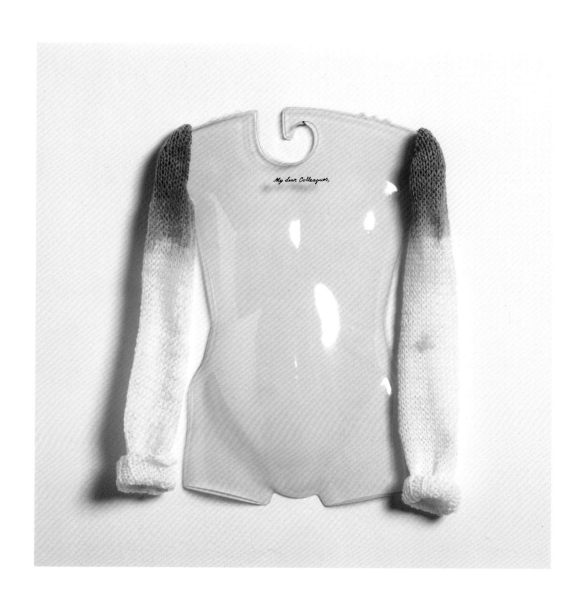

ROSEMARIE TROCKEL

My Dear Colleagues, 1986
Plastic and wool
51 x 40 x 8 cm

CHAPTER III.

textiles

Rosemarie Trockel
Judith Scott

ROSEMARIE TROCKEL

From a French Magazine, 2005
Silkscreen print on plastic
82 x 63 cm

ROSEMARIE TROCKEL

From a French Magazine, 2005
Silkscreen print on plastic
82 x 63 cm

ROSEMARIE TROCKEL

Bibliothek Babylon, 1997
Serigraph on plastic
120 x 90 cm

Untitled, 1986
Acrylic yarn
150 x 61 x 9 cm

144

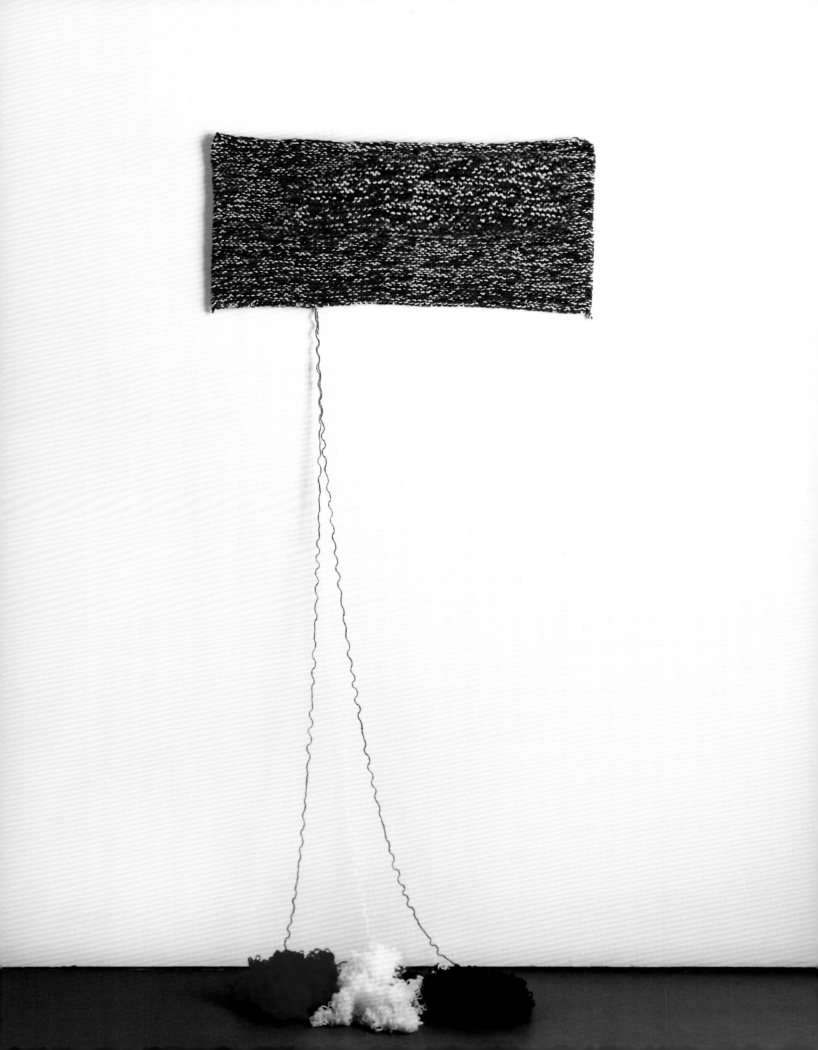

ROSEMARIE TROCKEL

Patti, 2000
Frames from video; black-and-white; sound; 2 min., 25 sec.

ROSEMARIE TROCKEL

À la Motte, 1993
Frames from video; black-and-white; silent; 1 min.

ROSEMARIE TROCKEL

Pausa, 1999
Frames from video; colour; silent; 1 min. 18 sec.

ROSEMARIE TROCKEL

Untitled (For Those Who Don't Like Wool Pictures
But Are Communists Nonetheless), 1988
Canvas, wool, and gesso
30 x 30 cm

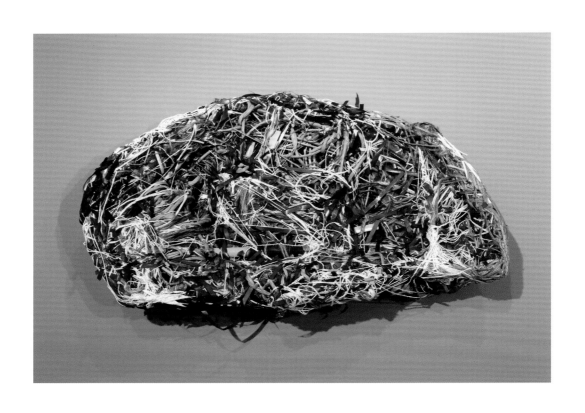

JUDITH SCOTT

Untitled (Nest), 1989
Mixed mediums
38.1 x 60.95 x 12.7 cm

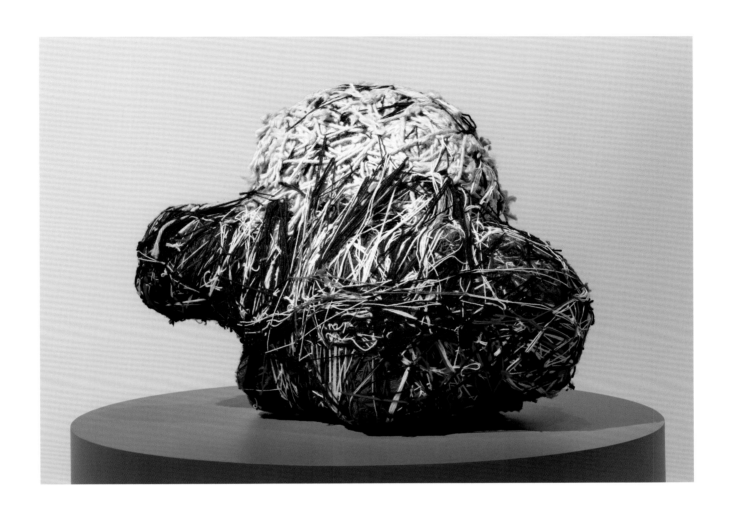

JUDITH SCOTT

Untitled, 1989
Mixed mediums
71.1 x 71.1 x 45.72 cm

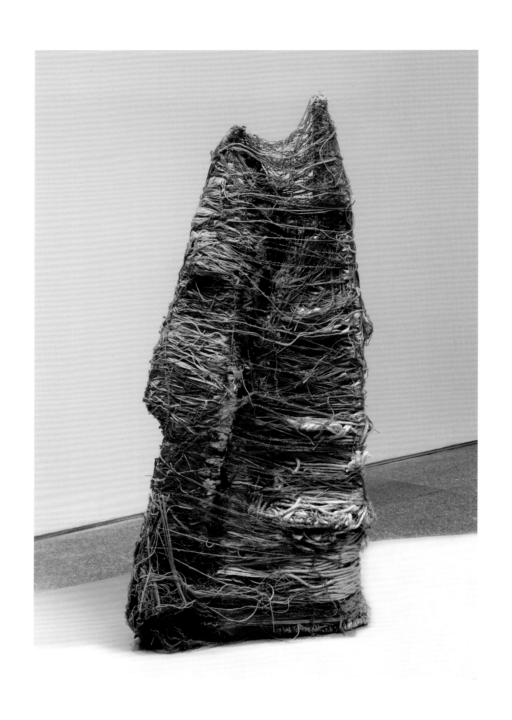

JUDITH SCOTT

Untitled, 1991
Mixed mediums
121.9 x 25.4 x 50.8 cm

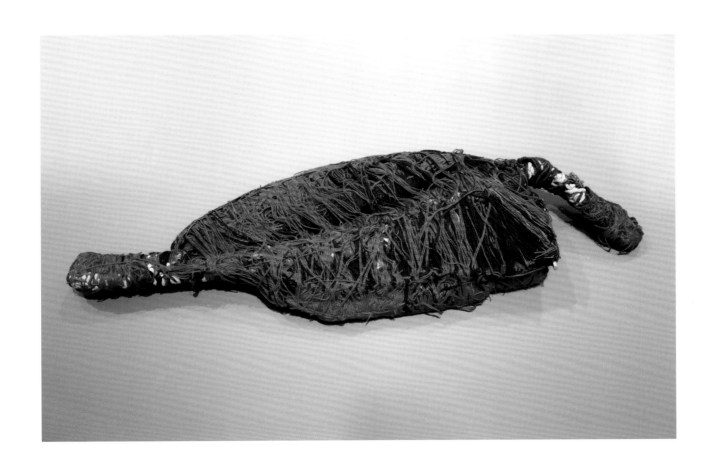

JUDITH SCOTT

Untitled, 1993
Mixed mediums
119.4 x 45.7 x 16.5 cm

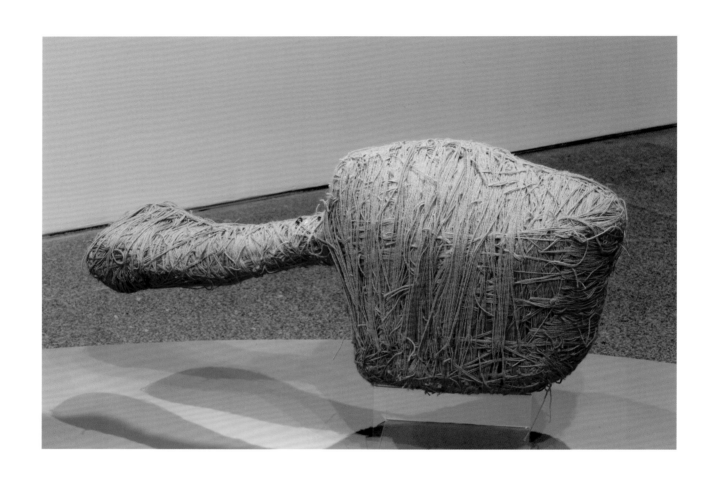

JUDITH SCOTT

Untitled, 1995
Mixed mediums
63 x 45 x 90 cm

154

JUDITH SCOTT

Untitled, 1993
Mixed mediums
66 x 53 x 20 cm

ROSEMARIE TROCKEL

Silent Way, 2012
Wool
120 x 90 cm

ROSEMARIE TROCKEL

Black Cab 1, 2011
Wool and perspex
100 x 100 cm

ROSEMARIE TROCKEL

Black Cab 2, 2011
Wool and perspex
100 x 100 cm

ROSEMARIE TROCKEL

Black Cab 3, 2011
Wool and perspex
100 x 100 cm

ROSEMARIE TROCKEL

Ghost, 2011
Wool and perspex
150 x 150 cm

ROSEMARIE TROCKEL

I See Darkness, 2011
Wool and perspex
90 x 90 cm

ROSEMARIE TROCKEL

I See Darkness, 2012
Wool and perspex
90,5 x 90 x 5 cm

ROSEMARIE TROCKEL

Belle Époque, 2011
Wool
130 x 150 cm

164

ROSEMARIE TROCKEL

Comfort Zone, 2012
Wool and perspex
100 x 100 cm

ROSEMARIE TROCKEL

Sky, 2012
Wool and wood
296 x 296 cm

166

ROSEMARIE TROCKEL

Kind of Blue, 2012
Wool and wood
296 x 296 cm

ROSEMARIE TROCKEL

Study for Kind of Blue, 2012
Wool and wood
100 x 100 cm

ROSEMARIE TROCKEL

The Same Procedure as Every Year, 2010
Wool and wood
200 x 100 cm

ROSEMARIE TROCKEL

Assisted Lines, 2011
Wool
110 x 110 cm

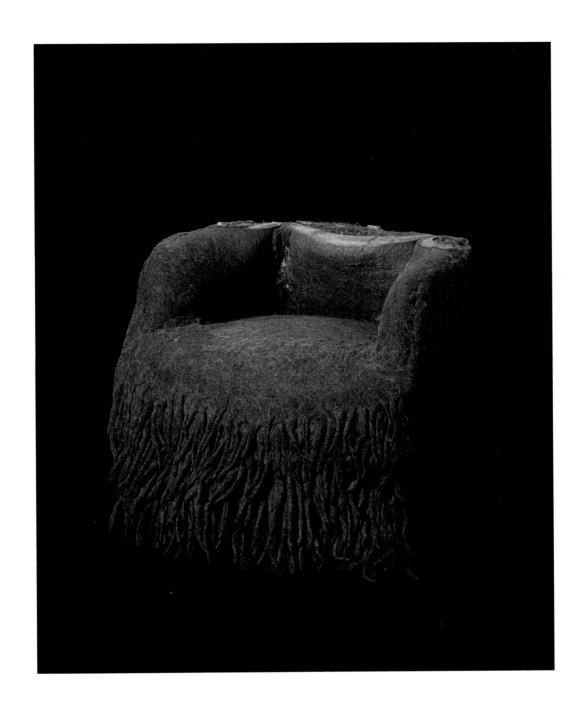

ROSEMARIE TROCKEL

Atheismus, 2007
Mixed mediums
63 x 76 x 65 cm

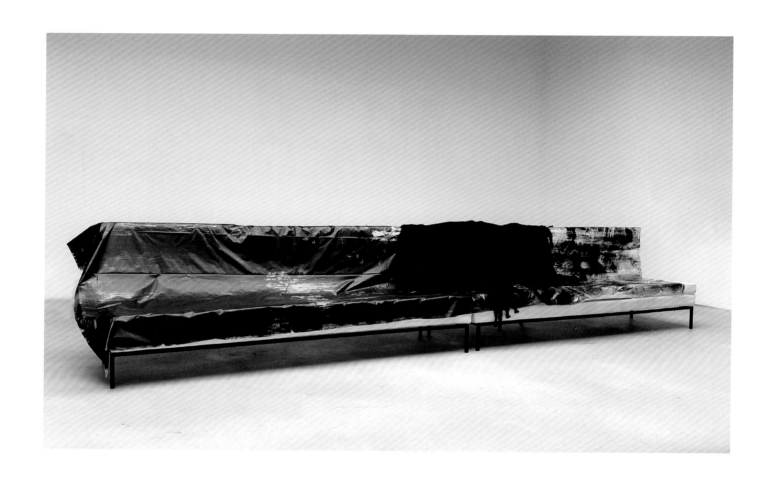

ROSEMARIE TROCKEL

Replace Me, 2011
Glass, steel, wool, fabric, plastic, and mixed mediums
80 x 420 x 71 cm

CHAPTER IV.

ceramics

Rosemarie Trockel

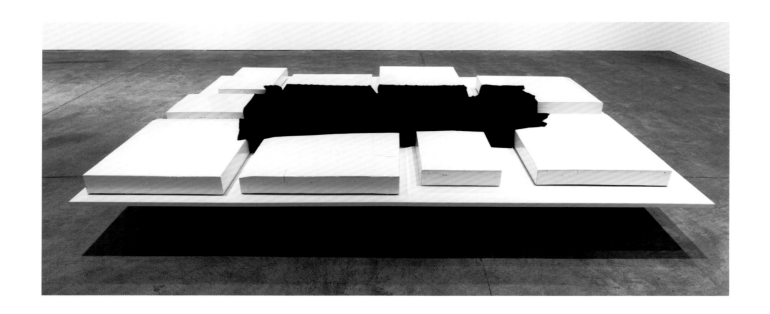

ROSEMARIE TROCKEL

Landscapian Shroud of My Mother, 2008
Steel and glazed ceramic
70 x 278 x 200 cm

174

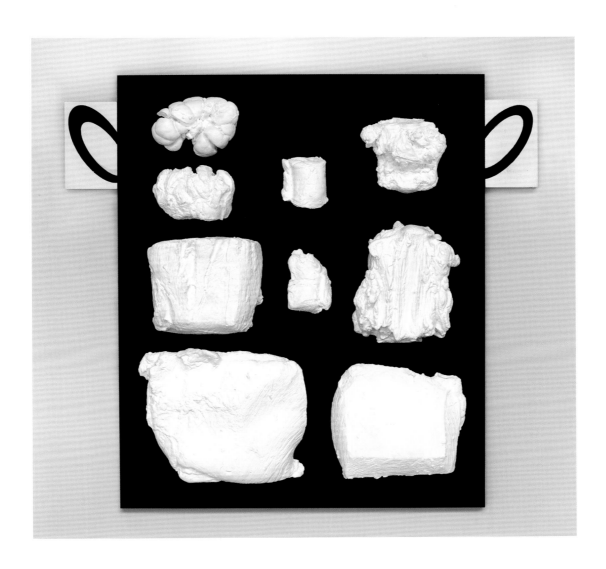

ROSEMARIE TROCKEL

Sprachwandel B, 2006
Ceramic, acrylic, and wood
50 x 42 x 9 cm

175

ROSEMARIE TROCKEL

Less Sauvages than Others, 2007
Platinum-glazed ceramic
64 x 79 x 13 cm

ROSEMARIE TROCKEL

Magma, 2008
Glazed ceramic
77 x 68 x 21 cm

ROSEMARIE TROCKEL

Shutter, 2006
Glazed ceramic
83 x 62 x 7 cm.

Grater 2, 2006
Platinum-glazed ceramic
322.6 x 259.1 x 5.1 cm

179

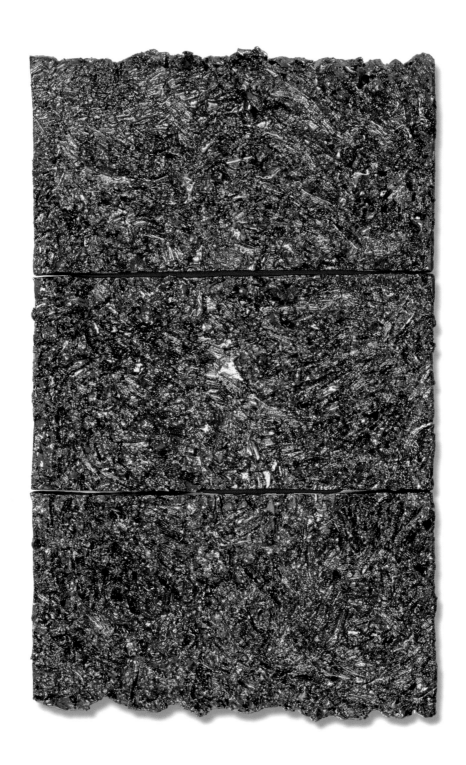

ROSEMARIE TROCKEL

Spiegelgrab, 2006
Platinum-glazed ceramic
178 x 106 x 8 cm

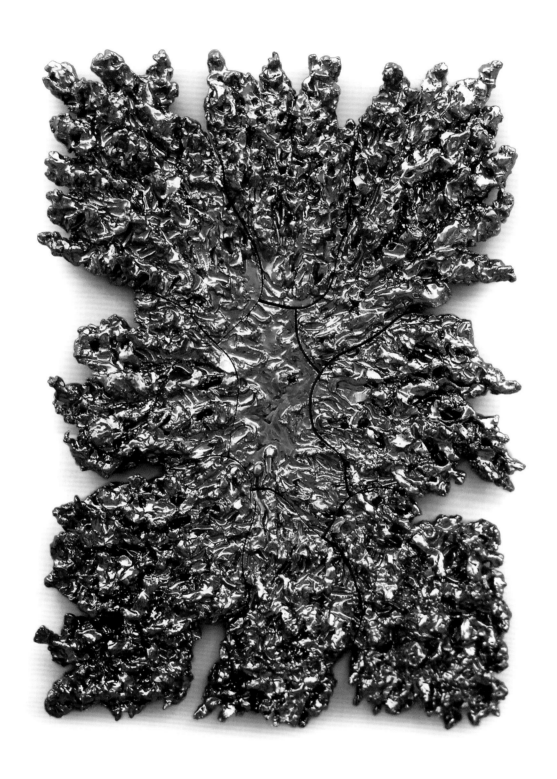

ROSEMARIE TROCKEL

Less Sauvages than Others, 2006
Platinum-glazed ceramic
180 x 125 x 19 cm

ROSEMARIE TROCKEL

Touchstone, 2012
Glazed ceramic
22 x 58 x 49 cm

ROSEMARIE TROCKEL

Made in China, 2012
Glazed ceramic
26 x 54 x 33 cm

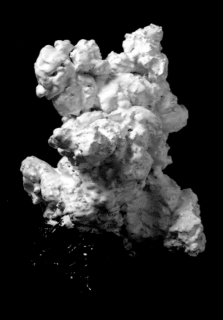

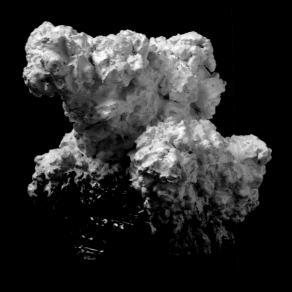

ROSEMARIE TROCKEL

Made in China, 2008
Glazed ceramic
39 x 35 cm

ROSEMARIE TROCKEL

Made in China, 2008
Glazed ceramic
39 x 30 cm

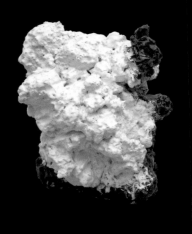

ROSEMARIE TROCKEL

Untitled, 2006
Platinum-glazed ceramic
c. 37 x 37 cm

ROSEMARIE TROCKEL

Twin 1, 2008
Glazed ceramic
33 x 33 x 33 cm

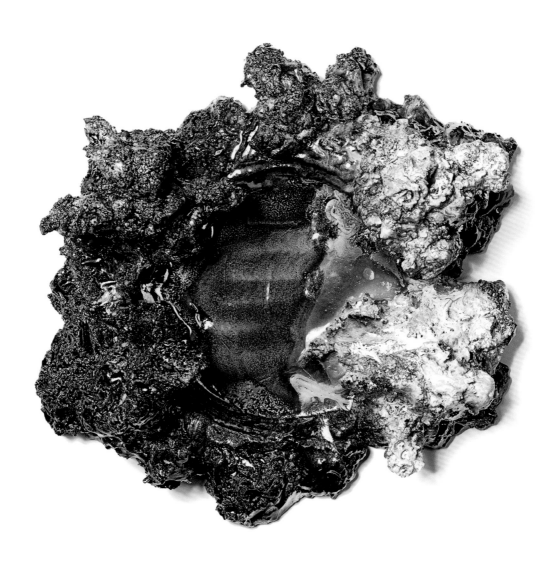

ROSEMARIE TROCKEL

Louvre 1, 2009
Platinum-glazed ceramic
60 x 57 x 24 cm

ROSEMARIE TROCKEL

General 1, 2008
Glazed ceramic and silver necklace
c. 35 x 30 x 20 cm

ROSEMARIE TROCKEL

Daily Trap, 2010
Ceramic and acrylic
104 x 94 x 10 cm

186

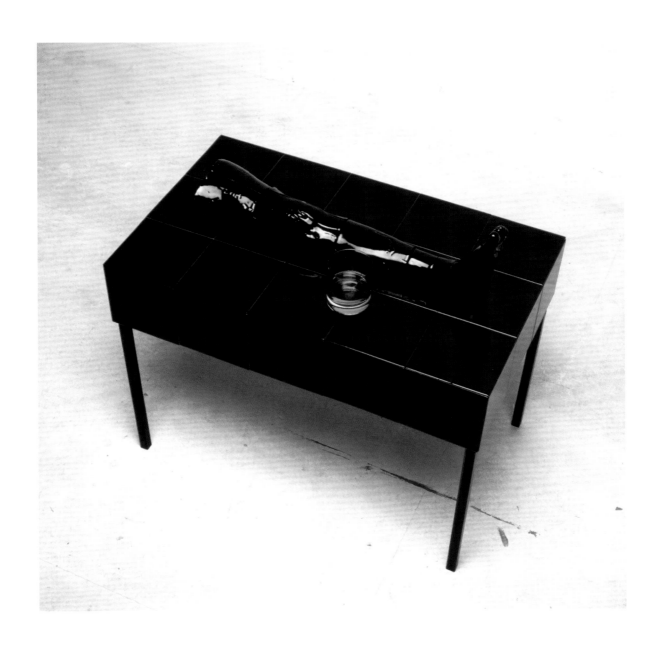

ROSEMARIE TROCKEL

Geruchsskulptur 2, 2006
Ceramic, glass, metal, and alcohol
75 x 46 x 76 cm

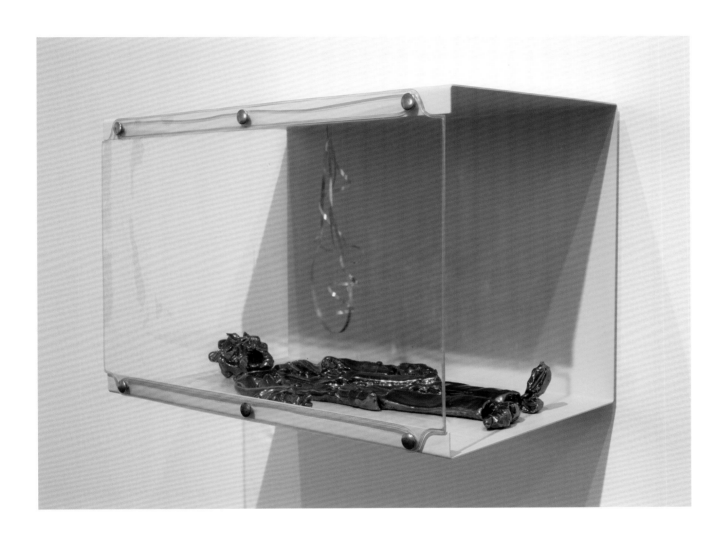

ROSEMARIE TROCKEL

German Spring, 2011
Glazed ceramic, perspex, metal, and paint
60 x 43 x 40 cm

ROSEMARIE TROCKEL

Training, 2011
Lacquered ceramic
60 x 90 x 10.5 cm

CHAPTER V.

books

Rosemarie Trockel
Ruth Francken
Manuel Montalvo

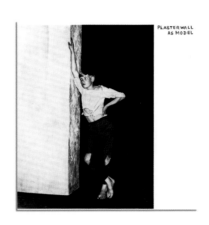

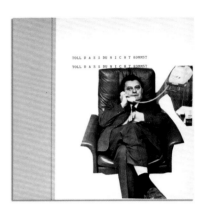

Else, 1970
25.7 x 19.7 cm

Plasterwall als Modell, 1982
21 x 20.1 cm

"Toll, dass du nicht kommst," 1982
20 x 19.7 cm

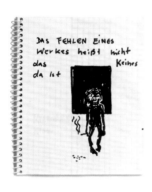

Notizbuch, 1982/83
14.4 x 12.3 cm

Golden Years, 1982/86
15.1 x 13.2 cm

Theoriephobie, 1983
20.7 x 14.8 cm

ROSEMARIE TROCKEL

Book drafts, 1971–2005
Mixed mediums
Variable dimensions

Phobia, 1988
20.8 x 20.8 cm

Gipsmodelle + Entwürfe, 1995
26.4 x 19.6 cm

I gave a party, 1983
20.5 x 13.8 cm

OB makes us bleed, 1984
16.5 x 10.8 cm

Meet me half way, 1984
20.4 x 14.4 cm

The next auction will be ..., 1984
20.4 x 14.4 cm

Ludwig, 1986
26.8 x 21.8 cm

/innen. Beiträge zur Ähnlichkeit, 1987
28.1 x 20.8 cm

ROSEMARIE TROCKEL

Book drafts, 1971–2005
Mixed mediums
Variable dimensions

Spiral Betty, 1988
26 x 18.9 cm

Lernen über Serielles Arbeiten, 1993
16.8 x 24.1 cm

SPINNEN ESSEN, 1995
23.4 x 14.9 cm

Education, 1995
14.6 x 15 cm

First Influenza, 1995
9.5 x 9.2 cm

arco de trimophe, 1997
25.4 x 20,3 cm

ROSEMARIE TROCKEL

Book drafts, 1971–2005
Mixed mediums
Variable dimensions

~~PAST~~

My favorite Couples 1

No Past, 1997
17.6 x 14 cm

four & seven n° 1 - 1969-70 four & seven n° 2 - 1970 **19** **20** mini-humpty - 1969 - 1970 R.F. avec four & seven n° 1 - 1969 - 1970 pandora n° 3 - 1968 pandora n° 3 - 1968 **21** | **22** connections - 1969 connections - 1969

RUTH FRANCKEN

Sculptures—objets—tableaux, 1971
37.3 x 38 cm (closed); 37.3 x 76 cm (open)
Illustration shows artist with *Four and Seven* (1969);
see p. 129

MANUEL MONTALVO

Untitled, c. 2000-2010
Handmade notebooks illustrated using various
graphic mediums
Variable dimensions; largest one shown is 14 x 11.5 x 8 cm

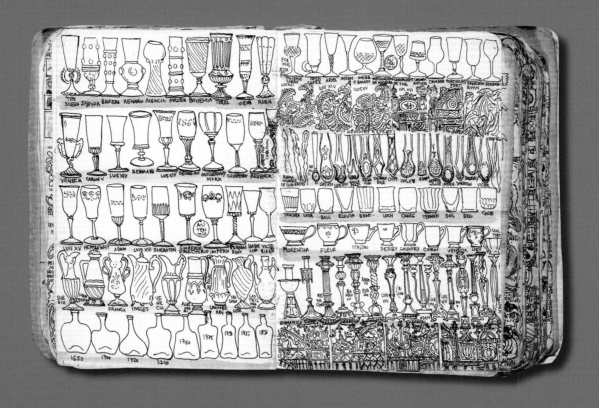

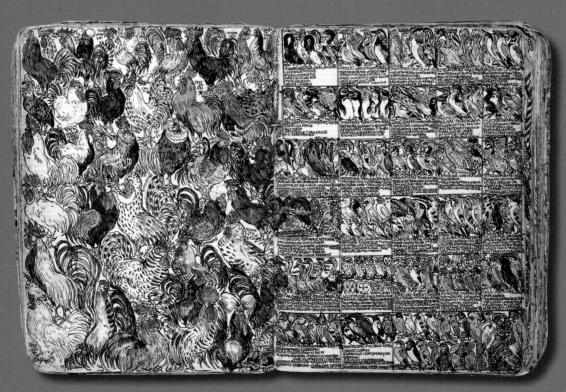

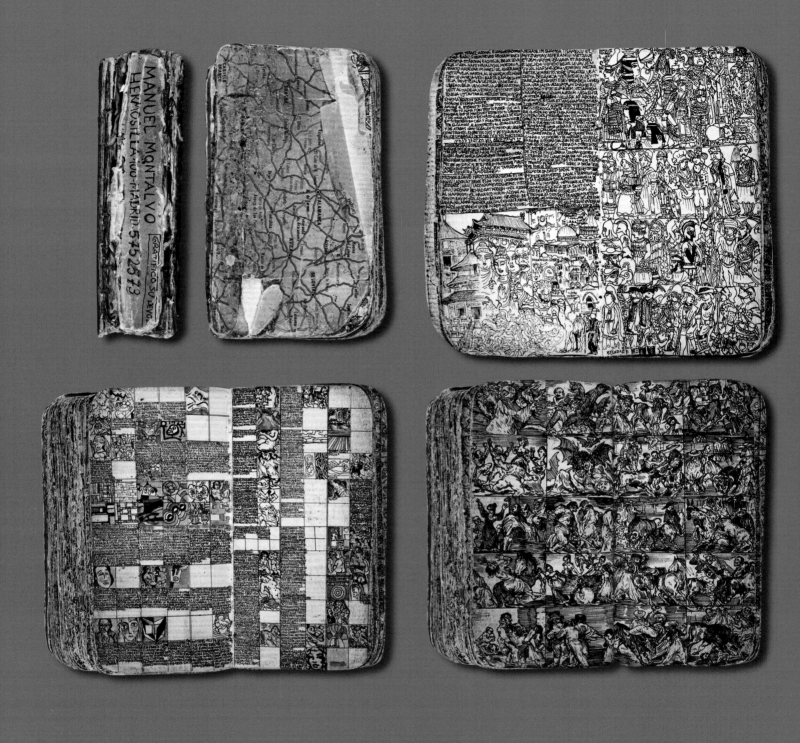

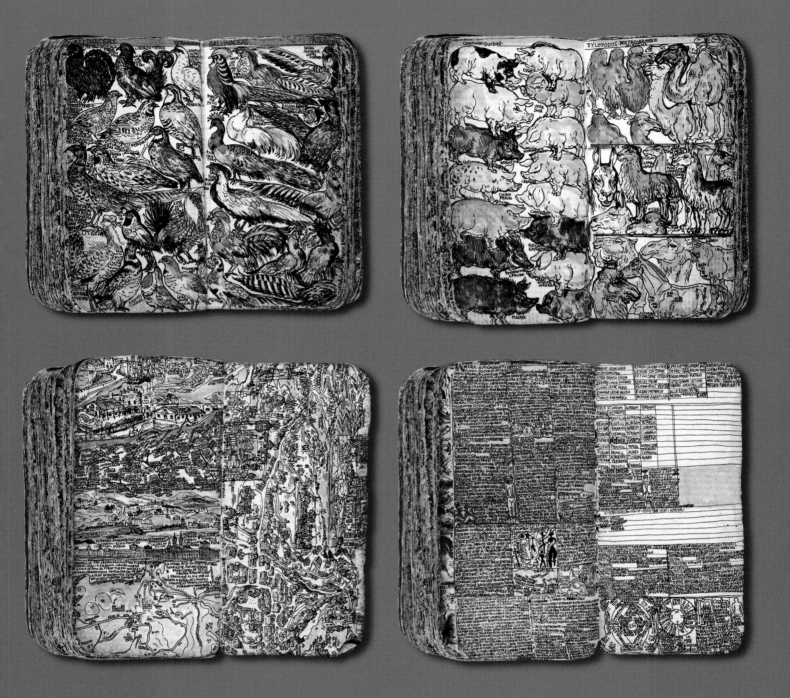

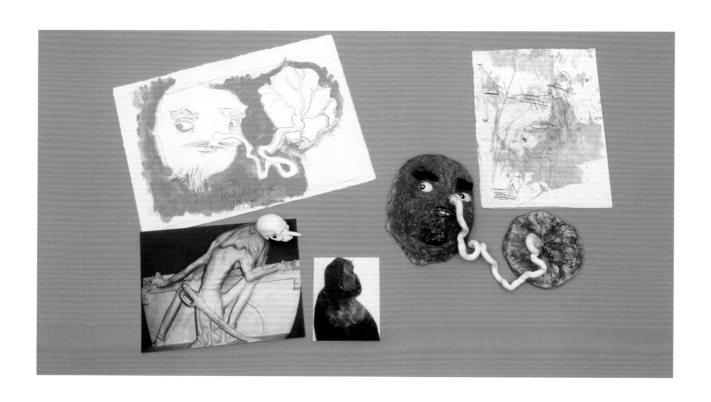

ROSEMARIE TROCKEL

Untitled, 1994
Two drawings: silicone, polyester paint, synthetic hair,
and paper; two photographs on paper; small bronze,
plastic and wood sculpture
Various dimensions

LIST OF WORKS

Japanese spider crab
Macrocheira kaempferi *(Majidae),*
mid-19th century
Crab specimen
207 x 77 x 23 cm
Museo Nacional de Ciencias Naturales,
CSIC, Madrid
[pp. 100-101]

After John James AUDUBON
by Robert HAVELL

Wood stork Mycteria americana
(Ciconiidae), 1834
Etching and aquatint on paper
84.5 x 61.4 cm
Purchased for the Society by public
subscription from Mr. John J. Audubon
Special Collections Research Center,
Syracuse University Library
[p. 94]

American flamingo Phoenicopterus ruber
(Phoenicopteridae), 1838
Etching and aquatint on paper
84.5 x 61.4 cm
Purchased for the Society by public
subscription from Mr. John J. Audubon
Special Collections Research Center,
Syracuse University Library
[p. 95]

Morton BARTLETT

Untitled (Ballerina), c. 1950
Black-and-white photograph on paper
10 x 12 cm
The Museum of Everything, London
[p. 113]

Untitled (Ballerina), c. 1950
Black-and-white photograph on paper
12 x 10 cm
The Museum of Everything, London
[p. 112]

Untitled (Ballerina), 1950-60
Polychrome plaster, synthetic hair, wood,
metal, and clothing
80 x 90 x 31 cm
The Museum of Everything, London

Untitled (Ballerina), c. 1955/2006
Chromogenic print on board
51.4 x 71.2 cm
Private collection
[p. 111]

Leopold and Rudolph
BLASCHKA

Golf tee medusa Aegina citrea *(Aeginidae),*
c. 1863-1890
Glass
22 x 8.5 x 8.5 cm
University of Aberdeen Museums,
Scotland
[p. 91]

Jellyfish Polyenia alderii,
c. 1863-1890
Glass
21 x 6.5 x 6.5 cm
University of Aberdeen Museums,
Scotland
[p. 90]

Jellyfish Porpita mediterranea
(Porpitidae), c. 1863-1890
Glass
21 x 8 x 8 cm
University of Aberdeen Museums,
Scotland
[p. 91]

Jellyfish Polyclonia frondosa,
c. 1876
Glass
9 x 6 x 21 cm
The Natural History Museum, London
[p. 92]

Moon jellyfish Aurelia aurita *(Ulmaridae),*
c. 1876
Glass
9 x 6 x 21 cm
The Natural History Museum, London
[p. 92]

Siphonophore Physophora myzonema
(Physophoridae), c. 1876
Glass
9 x 6 x 21 cm
The Natural History Museum, London
[p. 93]

James CASTLE

Untitled (CAS09-0039), n.d.
Found paper, soot, pigment of unknown
origin, graphite, string, and ribbon
48.26 x 36.83 cm
Jacqueline and Charles Crist, Boise, Idaho
[p. 98]

Untitled (CAS09-0042), n.d.
Found paper, string, and wood
12.7 x 18.1 cm
James Castle Collection and Archive, Boise,
Idaho
[p. 99]

Untitled (CAS09-0324), n.d.
Found paper, soot, pigment of unknown
origin, and string
73.03 x 25.4 cm
James Castle Collection and Archive, Boise,
Idaho

Untitled (CAS09-0325), n.d.
Found paper, soot, string, fabric, and hemp
53.34 x 36.83 cm
James Castle Collection and Archive, Boise,
Idaho
[p. 97]

Untitled (CAS10-0313), n.d.
Found paper, pigment of unknown origin,
and wheat paste
14.61 x 15.24 cm
James Castle Collection and Archive, Boise,
Idaho
[p. 96]

Untitled (CAS10-0314), n.d.
Found paper, soot, and wheat paste
12.07 x 11.75 cm
James Castle Collection and Archive, Boise,
Idaho
[p. 96]

Untitled (CAS10-0310), n.d.
Found paper, soot, wheat paste, and string
10.8 x 11.75 cm
James Castle Collection and Archive, Boise, Idaho
[p. 99]

Untitled (CAS11-0260), n.d.
Found paper, soot, pigment of unknown origin, and string
20.32 x 19.69 cm
James Castle Collection and Archive, Boise, Idaho
[p. 96]

Untitled (CAS11-0261), n.d.
Found paper, soot, pigment of unknown origin, string, ribbon, and cord
37.15 x 28.26 cm
James Castle Collection and Archive, Boise, Idaho

Untitled (CAS11-0262), n.d.
Found paper, soot, pigment of unknown origin, string, and fabric
39.37 x 40.01 cm
James Castle Collection and Archive, Boise, Idaho

Untitled (CAS11-0263), n.d.
Found paper, soot, pigment of unknown origin, and string
13.65 x 14.92 cm
James Castle Collection and Archive, Boise, Idaho

Untitled (CAS11-0264), n.d.
Found paper, soot, pigment of unknown origin, string, and cord
16.83 x 27.62 cm
James Castle Collection and Archive, Boise, Idaho
[p. 99]

Salvador DALÍ

Aphrodisiac Telephone, 1936
Plastic, plaster, and string
20.96 x 31.12 x 16.51 cm
The Minneapolis Institute of Arts, The William Hood Dunwoody Fund
[p. 126]

Mary DELANY

Primrose Primula vulgaris acaulis *(Petandria Monogynia)*, c. 1772-75
Collage of coloured papers, with bodycolor and watercolor, on black ink background
24.3 x 17.3 cm
The British Museum, London
[p. 76]

Climbing fumitory Fumaria fungosa *(Diadelphia Hexandria)*, 1776
Collage of coloured papers, with bodycolor and watercolor, on black ink background
26.8 x 21 cm
The British Museum, London
[p. 77]

Grass of Parnassus Parnassia palustris *(Pentandria Tetragynia)*, c. 1776
Collage of colored papers, with bodycolor and watercolor, and a leaf sample, on black ink background
31.3 x 22.6 cm
The British Museum, London
[p.76]

Ruth FRANCKEN

Four and Seven, 1969
Aluminum metal numbers, cushion, and other materials
118 x 85 x 85 cm
Galerie Yves Gastou, Paris
[p. 129]

Sculpture—objets—tableaux, 1971
Pamphlet printed on paper
Approximately 37.3 x 38 cm
Private collection
[pp. 198-99]

Eros et civilisation, 1972
Monkey fur, metal, black-and-white photograph, fabric, and perspex
153 x 119 x 6 cm
Centre Pompidou, Musée National d'Art Moderne, Paris
[p. 130]

L'anticastrateur, c. 1973
Silkscreen print on paper
86.5 x 61.5 cm
Private collection
[p. 127]

Maria Sibylla MERIAN

Caterpillar and Other Small Insects Made in Fine Miniature, inside a Golden Ellipse, before 1660
Tempera on parchment
12.1 x 16.5 cm
Kupferstichkabinett, Staatliche Museen, Berlin
[pp. 6, 89]

Caterpillar and Three Termites made in Fine Miniature, inside a Golden Ellipse, before 1660
Tempera on parchment
12.1 x 16.5 cm
Kupferstichkabinett, Staatliche Museen, Berlin
[p. 88]

Three Caterpillars and a Small Beetle Made in Fine Miniature, inside a Golden Ellipse, before 1660
Tempera on parchment
14.4 x 19.5 cm
Kupferstichkabinett, Staatliche Museen, Berlin
[p. 88]

Citron with a Moth and a Harlequin Beetle, c. 1701-2
Watercolour and bodycolour over pencil and etching on vellum
36.1 x 27.8 cm
The Royal Collection, Windsor
[p. 78]

Flower Plant and Flag-legged Bug, c. 1701-5
Watercolour and bodycolour over lightly etched outlines on vellum
38 x 28.8 cm
The Royal Collection, Windsor
[p. 79]

Metamorphosis Insectorum Surinamensium,
(1705) 1730
 Book of engravings
 58 x 40 cm
 Biblioteca del Museo Nacional de Ciencias
 Naturales, CSIC, Madrid
 [p. 87]

Manuel MONTALVO

Untitled, c. 2000–2010
 Handmade notebook illustrated using
 various graphic mediums
 14 x 10 x 2.7 cm
 Familia Montalvo

Untitled, c. 2000–2010
 Handmade notebook illustrated using
 various graphic mediums
 14 x 11.5 x 8 cm
 Familia Montalvo

Untitled, c. 2000–2010
 Handmade notebook illustrated using
 various graphic mediums
 12.6 x 11 x 3.4 cm
 Familia Montalvo

Untitled, c. 2000–2010
 Handmade notebook illustrated using
 various graphic mediums
 12 x 7 x 3 cm
 Familia Montalvo

Untitled, c. 2000–2010
 Handmade notebook illustrated using
 various graphic mediums
 10.6 x 8 x 4 cm
 Familia Montalvo

Untitled, c. 2000–2010
 Handmade notebook illustrated using
 various graphic mediums
 12 x 9.5 x 3 cm
 Familia Montalvo

Untitled, c. 2000–2010
 Handmade notebook illustrated using
 various graphic mediums
 14.6 x 11 x 6 cm
 Familia Montalvo

Untitled, c. 2000–2010
 Handmade notebook illustrated using
 various graphic mediums
 14 x 11 x 3 cm
 Lola Montalvo

Untitled, c. 2000–2010
 Handmade notebook illustrated using
 various graphic mediums
 11.6 x 8.3 x 2.2 cm
 Lola Montalvo

Untitled, c. 2000–2010
 Handmade notebook illustrated using
 various graphic mediums
 12 x 9.5 x 3 cm
 Lola Montalvo

Untitled, c. 2000–2010
 Handmade notebook illustrated using
 graphic mediums
 9.6 x 6.8 x 3 cm
 Familia Montalvo Cleofé

Untitled, c. 2000–2010
 Handmade notebook illustrated with
 graphic mediums
 4.5 x 7 x 2.3 cm
 Familia Montalvo Cleofé

 [pp. 200–205]

José Celestino MUTIS,
Director, Royal Botanical Expedition to
New Granada (1783–1816)

ANONYMOUS

Aristolochia cordiflora Mutis ex Kunth
(Aristolochiaceae), (DIV. III A-891-b), n.d.
 Ink on paper
 54.6 x 38 cm
 Archivo Real Jardín Botánico, CSIC,
 Madrid
 [p. 72]

Aristolochia sp. (Aristolochiaceae)
(DIV. III A-891-c), n.d.
 Tempera on paper
 54.6 x 38 cm
 Archivo Real Jardín Botánico, CSIC,
 Madrid
 [p. 72]

Aristolochia sp. (Aristolochiaceae)
(DIV. III A-892-c), n.d.
 Tempera on paper
 54.6 x 38 cm
 Archivo Real Jardín Botánico, CSIC,
 Madrid
 [p. 73]

Kyllinga pumila Michx. (Cyperaceae)
(DIV. III A-200), n.d.
 Tempera on paper
 54.6 x 38 cm
 Archivo Real Jardín Botánico, CSIC,
 Madrid
 [p. 75]

Scleria secans Urb. (Cyperaceae)
(DIV. III A-187), n.d.
 Tempera on paper
 54.6 x 38 cm
 Archivo Real Jardín Botánico, CSIC,
 Madrid
 [p. 74]

Untitled (DIV. III A-207), n.d.
 Tempera on paper
 54.6 x 38 cm
 Archivo Real Jardín Botánico, CSIC,
 Madrid

Pablo Antonio GARCÍA DEL CAMPO

Ciclantacea dicranopygium sp.
(Cyclanthaceae) (DIV. III A-633-a),
n.d.
 Tempera on paper
 54.6 x 38 cm
 Archivo Real Jardín Botánico, CSIC,
 Madrid

Francisco Javier MATIS MAHECHA

Plumeria sp. (Apocynaceae)
(DIV. III A-1364), n.d.
 Tempera on paper
 54.6 x 38 cm
 Archivo Real Jardín Botánico, CSIC,
 Madrid
 [p. 75]

Judith SCOTT

Untitled (Nest), 1989
 Mixed mediums
 38.1 x 60.95 x 12.7 cm
 Louis-Dreyfus Family Collection
 [p. 150]

Untitled, 1989
 Mixed mediums
 71.1 x 71.1 x 45.72 cm
 Louis-Dreyfus Family Collection
 [p. 151]

Untitled, 1991
 Mixed mediums
 121.9 x 25.4 x 50.8 cm
 Creative Growth Art Center, Oakland
 [p. 152]

Untitled, 1993
 Mixed mediums
 119.4 x 45.7 x 16.5 cm
 Creative Growth Art Center, Oakland
 [p. 153]

Untitled, 1993
 Mixed mediums
 66 x 53 x 20 cm
 The Museum of Everything, London
 [p. 155]

Untitled, 1995
 Mixed mediums
 63 x 45 x 90 cm
 The Museum of Everything, London
 [p. 154]

Wladyslaw STAREWICZ

The Cameraman's Revenge, 1912
 35 mm film transferred to video; tinted
 black-and-white; sound added later; 13 min.
 [pp. 108–10]

Rosemarie TROCKEL

Book drafts, 1971–2005
 Installation of 132 works on paper
 with mixed mediums
 Variable dimensions
 Private collection
 [pp. 30, 192–97]

Untitled, 1985
 Plaster and paint
 13 x 20 x 8 cm
 Private collection
 [p. 139]

My Dear Colleagues, 1986
 Plastic and wool
 51 x 40 x 8 cm
 Private collection, Cologne
 [p. 140]

Untitled, 1986
 Acrylic yarn
 150 x 61 x 9 cm
 Ringier Collection, Switzerland
 [p. 145]

Untitled (For Those Who Don't Like Wool Pictures But Are Communists Nonetheless), 1988
 Canvas, wool, and gesso
 30 x 30 cm
 Private collection
 [p. 149]

In Raven-Black Nights I Hear Ghosts and See Employees, 1989
 Felt pen, cardboard, and box
 32.5 x 43 x 5.5 cm
 Private collection
 [p. 121]

Untitled (Alone at Night I Read My Bible More and Euklid Less), 1989
 Stencil, ink, silver chain, and cardboard
 106.7 x 34.9 x 33 cm
 Courtesy of Sprüth Magers Berlin London
 [p. 120]

À la Motte, 1993
 Video; black-and-white; silent; 1 min.
 Private collection
 [p. 147]

Untitled 3, 1993
 Wood and synthetic hair
 100 x 100 x 140 cm
 Private collection, Zürich
 [p. 122]

Untitled, 1994
 Two drawings: silicone, polyester paint,
 synthetic hair, and paper; two photographs
 on paper; small bronze, plastic, and wood
 sculpture
 Various dimensions
 Private collection
 [p. 206]

Mechanical Reproduction, 1995
 Acrylic on paper
 20.5 x 25.5 cm
 Private collection
 [p. 70]

Mechanical Reproduction, 1995
 Pencil on paper
 26 x 27.8 cm
 Private collection
 [p. 71]

Aus Yvonne, 1997
 Plastic, wood, paint, polystyrene,
 and fabric
 72.5 x 30 x 30 cm
 Private collection
 [p. 116]

Bibliothek Babylon, 1997
 Serigraph on plastic
 120 x 90 cm
 Private collection
 [p. 144]

Pausa, 1999
 Video; colour; silent; 1 min. 18 sec.
 Private collection
 [p. 148]

Possibilities, 1999
 Digital print on metal, perspex,
 and cardboard
 40 x 39 x 1 cm
 Private collection
 [p. 125]

Patti, 2000
 Video; black-and-white; sound; 2 min., 25 sec.
 Private collection
 [p. 146]

Stell Dir vor / Imagine (aus Manus Spleen 2),
2002
 Silicone, fabric, glass, wood, and plastic
 53 x 58 x 29 cm
 Private collection
 [p. 117]

Mosquito Fighter, 2004
 Silicone
 117 x 26 x 2.3 cm
 Private collection
 [p. 131]

From a French Magazine, 2005
 Silkscreen print on plastic
 82 x 63 cm
 Private collection
 [p. 142]

From a French Magazine, 2005
 Silkscreen print on plastic
 82 x 63 cm
 Private collection
 [p. 143]

Geruchsskulptur 2, 2006
 Ceramic, glass, metal, and alcohol
 75 x 46 x 76 cm
 Courtesy of Sprüth Magers Berlin London
 [p. 187]

Grater 2, 2006
 Platinum-glazed ceramic
 322.6 x 259.1 x 5.1 cm
 The Art Institute of Chicago, Gift of
 Society for Contemporary Art 2007.363
 [p. 179]

Less Sauvages than Others, 2006
 Platinum-glazed ceramic
 180 x 125 x 19 cm
 Private collection
 [p. 181]

Park Avenue, 2006/2011
 23 35 mm color slides
 Private collection
 [pp. 80–81]

Shutter, 2006
 Glazed ceramic
 83 x 62 x 7 cm
 Courtesy of Sprüth Magers Berlin London;
 Barbara Gladstone Gallery, New York
 [p. 178]

Spiegelgrab, 2006
 Platinum-glazed ceramic
 178 x 106 x 8 cm
 Courtesy of Sprüth Magers Berlin London
 [p. 180]

Sprachwandel B, 2006
 Ceramic, acrylic, and wood
 50 x 42 x 9 cm
 Private collection
 [pp. 8, 175]

Untitled, 2006
 Platinum-glazed ceramic
 Approx. 37 x 37 cm
 Private collection
 [p. 183]

Atheismus, 2007
 Mixed mediums
 63 x 76 x 65 cm
 Kunstmuseum Bonn
 [p. 171]

Less Sauvages than Others, 2007
 Platinum-glazed ceramic
 64 x 79 x 13 cm
 Private collection
 [p. 176]

General 1, 2008
 Glazed ceramic and silver necklace
 Approx. 35 x 30 x 20 cm
 Courtesy of Galerie Crone, Berlin
 [p. 185]

Kiss My Aura, 2008
 Metal, feathers, and plaster
 65 x 25 x 25 cm
 Courtesy of Sprüth Magers Berlin London
 [p. 118]

Landscapian Shroud of My Mother, 2008
 Steel and glazed ceramic
 70 x 278 x 200 cm
 Courtesy of Sprüth Magers Berlin London
 [p. 174]

Made in China, 2008
 Glazed ceramic
 39 x 30 cm
 Private collection
 [p. 183]

Made in China, 2008
 Glazed ceramic
 39 x 35 cm
 Private collection
 [p. 183]

Magma, 2008
 Glazed ceramic
 77 x 68 x 21 cm
 Courtesy of Sprüth Magers Berlin
 London
 [p. 177]

Twin 1, 2008
 Glazed ceramic
 33 x 33 x 33 cm
 Private collection, Berlin
 [p. 183]

Louvre I, 2009
 Platinum-glazed ceramic
 60 x 57 x 24 cm
 Private collection, Zürich
 [p. 184]

Candleholder, 2010
 Graphite, acrylic, and silkscreen print
 on canvas
 48.9 x 48 cm
 Private collection
 [p. 86]

Daily Trap, 2010
 Ceramic and acrylic
 104 x 94 x 10 cm
 Courtesy of Sprüth Magers Berlin
 London; Barbara Gladstone Gallery,
 New York
 [p. 186]

Departure, 2010
 Acrylic, graphite, and paper on paper
 39 x 44.5 cm
 Private collection
 [p. 83]

Florence, 2010
 Acrylic and graphite on paper
 56.5 x 49.5 cm
 Private collection
 [p. 84]

The Same Procedure as Every Year, 2010
 Wool and wood
 200 x 100 cm
 Courtesy of Sprüth Magers Berlin London
 [p. 169]

Spiral Betty, 2010
 Neon, glass, acrylic, cord, cable, and plug
 150 x 35 x 10 cm
 Private collection
 [p. 138]

Assisted Lines, 2011
 Wool
 110 x 110 cm
 Private collection
 [p. 170]

Belle Époque, 2011
 Wool
 130 x 150 cm
 Private collection
 [p. 164]

Black Cab 1, 2011
 Wool and perspex
 100 x 100 cm
 Private collection
 [p. 158]

Black Cab 2, 2011
 Wool and perspex
 100 x 100 cm
 Courtesy of Sprüth Magers Berlin London;
 Barbara Gladstone Gallery, New York
 [p. 159]

Black Cab 3, 2011
 Wool and perspex
 100 x 100 cm
 Courtesy of Sprüth Magers Berlin London
 [p. 160]

German Spring, 2011
 Glazed ceramic, perspex, metal, and paint
 60 x 43 x 40 cm
 Private collection
 [p. 189]

Ghost, 2011
 Wool and perspex
 150 x 150 cm
 Private collection
 [p. 161]

Go Away Bird, 2011
 Digital print on cardboard
 64 x 62 x 2 cm
 Private collection
 [pp. 2, 12]

I See Darkness, 2011
 Wool and perspex
 90 x 90 cm
 Courtesy of Sprüth Magers Berlin London
 [p. 162]

Paws Down, 2011
 Digital print on cardboard
 20.5 x 25.5 cm
 Private collection
 [p. 68]

Question of Time, 2011
 Wool and perspex
 100 x 130 cm
 Private collection
 [p. 134]

Reborn with Spot, 2011
 Oil on canvas
 76 x 61 cm
 Private collection
 [p. 114]

Replace Me, 2011
 Digital print
 60 x 90 cm
 Private collection
 [p. 115]

Replace Me, 2011
 Glass, steel, wool, fabric, plastic, and
 mixed mediums
 80 x 420 x 71 cm
 Private collection
 [p. 172]

Retour au vestiaire, 2011
 Digital print and acrylic
 85 x 60 cm
 Private collection
 [p. 132]

Retour au vestiaire, 2011
 Digital print and acrylic
 85 x 60 cm
 Private collection
 [p. 133]

Training, 2011
 Lacquered ceramic
 60 x 90 x 10.5 cm
 Courtesy of Sprüth Magers Berlin
 London
 [p. 190]

As Far as Possible, 2012
 Steel, plastic, fabric, mechanical birds,
 glass, audio, and wood
 90 x 190 x 45 cm
 Private collection
 [pp. 106-7]

Comfort Zone, 2012
 Wool and perspex
 100 x 100 cm
 Private collection
 [p. 165]

I See Darkness, 2012
 Wool and perspex
 90.5 x 90 x 5 cm
 Private collection
 [p. 163]

Kind of Blue, 2012
 Wool and wood
 296 x 296 cm
 Courtesy of Sprüth Magers Berlin
 London
 [p. 167]

Less Sauvages than Others, 2012
 Painting made by the ourangutan Tilda,
 and perspex
 Three pieces, each measuring 80 x 80 cm
 Private collection
 [pp. 103-5]

Lucky Devil, 2012
 Crab specimen, perspex, and textile
 90 x 77 x 77 cm
 Private collection
 [p. 102]

Made in China, 2012
 Glazed ceramic
 26 x 54 x 33 cm
 Courtesy of Sprüth Magers Berlin
 London
 [p. 182]

Picnic, 2012
 Mixed mediums
 150 x 100 x 16 cm
 Private collection
 [p. 82]

Prima-Age, 2012
 Digital print on cardboard
 42 x 42 cm
 Private collection
 [p. 69]

Silent Way, 2012
 Wool
 120 x 90 cm
 Private collection
 [p. 157]

Sky, 2012
 Wool and wood
 296 x 296 cm
 Courtesy of Sprüth Magers Berlin
 London; Barbara Gladstone Gallery,
 New York
 [p. 166]

Study for Kind of Blue, 2012
 Wool and wood
 100 x 100 cm
 Private collection
 [p. 168]

Touchstone, 2012
 Glazed ceramic
 22 x 58 x 49 cm
 Private collection
 [p. 182]

*Was ein Ding ist, und was es nicht ist,
sind in der Form identisch, gleich*, 2012
 Ceramic, wood, glass, rubber, paper,
 and fabric
 152 x 53 cm (diameter)
 Private collection
 [p. 135]

Rosemarie TROCKEL
in collaboration with
Günter WESELER

Fly Me to the Moon, 2011
 Mixed mediums and electrical mechanism
 166 x 100 x 55 cm
 Private collection, Cosar HMT
 [pp. 136-37]

Günter WESELER

*Atemobjekte New Species U 90 /73 (Nr. 15,
Nr. 16)*, 1973
 Synthetic fur and electrical mechanism
 20 x 40 cm (diameter) each
 Private collection
 [p. 123]

Objekt für Atemtraining, 1969
 Plastic disc, synthetic fur, and balloon
 4 x 13 cm (diameter)
 Private collection
 [p. 124]

SELECTED BIBLIOGRAPHY

BOOKS AND CATALOGUES

Armstrong, Carol, and Catherine de Zegher, eds. *Women Artists at the Millennium*. Cambridge, MA: MIT Press, 2006.

Benjamin, Andrew, ed. *The Lyotard Reader*. Oxford: Blackwell Publishers, 1989.

Brafman, David, and Stephanie Schrader. *Insects & Flowers: The Art of Maria Sibylla Merian*. Los Angeles: The J. Paul Getty Museum, 2008.

Cooke, Lynne, ed. *James Castle: Show and Store*. Madrid: Museo Nacional Centro de Arte Reina Sofía; New York: D.A.P./Distributed Art Publishers, Inc., 2011.

Dalí, Salvador, and A. Reynolds Morse, eds. *Salvador Dalí: A Panorama of His Art*. Cleveland: Salvador Dalí Museum, 1974.

Davis, Natalie Zemon. *Women on the Margins: Three Seventeenth-Century Lives*. Cambridge, Mass.: Harvard University Press, 1995.

Doutrebente, Olivier. *Succession Ruth Francken: Vente aux Enchères Publiques: Vendredi 21 septembre 2007*. Paris: Maison de Ventes aux Enchères SARL, 2007.

Engelbach, Barbara, ed. *Rosemarie Trockel: Post-Menopause*. Cologne: Museum Ludwig, 2005.

Günter Weseler, exh.cat. Bonn: Galerie Hennemann and Taschenbuch, 1977.

Kittelmann, Udo, and Claudia Dichter, eds. *Morton Bartlett*. Cologne: Verlag der Buchhandlung Walther König; Berlin: Nationalgalerie, Staatliche Museen, 2012.

Laird, Mark, and Alicia Weisberg-Roberts, eds. *Mrs. Delany and Her Circle*. New Haven: Yale University Press, 2009.

Leopold & Rudolf Blaschka. London: Design Museum and TwoTen Gallery; Sunderland: National Glass Centre, 2002.

MacGregor, John M. *Metamorphosis: The Fiber Art of Judith Scott: The Outsider Artist and the Experience of Down's Syndrome*. Oakland: Creative Growth Art Center, 1999.

O'Malley, Therese, and R. W. Amy Meyeres, eds. *The Art of Natural History: Illustrated Treatises and Botanical Paintings, 1400–1850*. Washington: National Gallery of Art, 2008.

Peacock, Molly. *The Paper Garden: An Artist {Begins Her Life's Work} at 72*. New York: Bloombury USA, 2010.

Percy, Ann, ed. *James Castle: A Retrospective*. Philadelphia: Philadelphia Museum of Art; New Haven, Conn.: Yale University Press, 2008.

Reitsma, Ella. *Maria Sibylla Merian & Daughters: Women of Art and Science*. Amsterdam: The Rembrandt House Museum; Los Angeles: The J. Paul Getty Museum; Zwolle, Netherlands: Waanders Publishers, 2008.

Rhodes, Richard. *John James Audubon: The Making of an American*. New York: Alfred A. Knopf, 2004.

Rosemarie Trockel: Bodies of Work, 1986–1998. Cologne: Oktagon Verlag, 1998.

Rosemarie Trockel: Kaiserringträgerin der Stadt Goslar 2011. Berlin: Mönchehaus Museum Goslar, 2011.

Ruth Francken: sculptures-objects-tableaux. Paris: Musée d'Art Moderne de la Ville de Paris, 1971.

San Pío Aladrén, María Pilar de, and Shirley Sherwood. *Old and New South American Botanical Art: The Mutis & Shirley Sherwood Collections*. Madrid: Real Jardín Botánico, CSIC, 2010.

Saunders, Gill. *Picturing Plants: An Analytical History of Botanical Illustration*. London: Zwemmer in association with The Victoria and Albert Museum, 1995.

Schumacher, Rainald, ed. *Rosemarie Trockel*. Munich: Sammlung Goetz, 2002.

Souder, William M. *Under a Wild Sky: John James Audubon and the Making of The Birds of America*. New York: North Point Press, 2004.

Stich, Sidra, ed. *Rosemarie Trockel*. Boston: The Institute of Contemporary Art; Berkeley: University Art Museum; Munich: Prestel, 1991.

MAGAZINES AND WEB RESOURCES

Ford, Charles. "Ladislas Starevitch: The Pioneer with Puppets on Film Has Persevered Despite War and Revolution." *Films in Review*, April 1958: pp. 191–92, 216.

Francken, Ruth. "Connections." N.d. http://www.costis.org/x/francken/connections.htm (accessed May 2012).

Lyotard, J. F. "The Story of Ruth." 1983 http://www.costis.org/x/francken/story.htm (accessed May 2012).

Rowland, Ingrid D. "The Flowering Genius of Maria Sibylla Merian." *The New York Review of Books*, April 2009 http://www.nybooks.com/articles/archives/2009/apr/09/the-flowering-genius-of-maria-sibylla-merian (accessed May 2012).

Schneider, Eric. "Entomology and Animation: A Portrait of an Early Master Ladislaw Starewicz." *Animation World Magazine*, Issue 5.02, May 2000 http://www.awn.com/mag/issue5.02/5.02pages/schneiderstarewicz.php3 (accessed May 2012).

Seton, Marie. "The Modern Aesop [Starewicz]." *World Film News*, October 1936 http://ls.pagesperso-orange.fr/tmseton.htm (accessed May 2012).

Simmons, Laurie. "Guy and Dolls: The Art of Morton Bartlett." *Artforum*, September 2003: pp. 204-7, 261.

CONTRIBUTORS

Dore Ashton is among the world's most authoritative critics of modern and contemporary art. She is the author or editor of thirty books on art and culture, including *Noguchi East and West*; *About Rothko*; *American Art Since 1945*; *Rosa Bonheur in Her Time* (with Denise Browne Hare); *A Fable of Modern Art*; *Yes, But: A Critical Study of Philip Guston*; *A Joseph Cornell Album*; *The New York School: A Cultural Reckoning*; *Picasso on Art*; *The Sculpture of Pol Bury*; *Richard Lindner*; *Rauschenberg's* Dante; *The Unknown Shore*; *Redon, Moreau, Bresdin*; *Philip Guston*; *Poets and the Past*; *Abstract Art Before Columbus*; and *David Smith: Medals for Dishonor*. She has won many awards and recognitions, including Guggenheim Foundation Fellowships in 1963 and 1969. Ms. Ashton is a professor of art history at the Cooper Union in New York and was appointed senior critic in painting/printmaking at Yale in 2002.

Lynne Cooke was appointed chief curator and deputy director of the Museo Nacional Centro de Arte Reina Sofía, Madrid, in 2008. From 1991 through 2008 she was curator at Dia Art Foundation, New York. Co-curator of the 1991 Carnegie International and artistic director of the 1996 Sydney Biennale, she has also curated exhibitions in numerous venues in North America, Europe, and elsewhere. In 2000 she received the Independent Curators International Agnes Gund Curatorial Award, and in 2006 she received the Award for Curatorial Excellence from the Center for Curatorial Studies, Bard College. Among her numerous publications are recent essays on the works of Francis Alÿs, Zoe Leonard, Agnes Martin, Blinky Palermo, and Dorit Margreiter.

Suzanne Hudson received her Ph.D. from Princeton University and is currently Assistant Professor of Modern and Contemporary Art at the University of Southern California. She is co-founder of the Contemporary Art Think Tank and President Emerita and Chair of the Executive Committee of the Society of Contemporary Art Historians, an affiliate society of the College Art Association. Her writings have appeared in *Parkett, Flash Art, Art Journal*, and *October*, and she is a regular contributor to *Artforum*. She is the author of *Robert Ryman: Used Paint* (2009) and two forthcoming titles, *Contemporary Art: 1989–Present*, with Alexander Dumbadze, and *Painting Now*. She is currently at work on a manuscript on art and spirituality in 1960s America.

Anne M. Wagner is Class of 1936 Chair Emerita in the Department of History of Art at the University of California, Berkeley. Her many essays have appeared in journals including *Artforum, Representations, October*, and *The Threepenny Review*. She is the author of *Jean-Baptiste Carpeaux: Sculptor of the Second Empire* and *Three Artists (Three Women)*. Her third book, *Mother Stone: The Vitality of Modern British Sculpture*, brought a feminist perspective to the work of sculptors like Henry Moore and Barbara Hepworth, and a book of her essays, *A House Divided: On Recent American Art*, published in 2012, explored questions of artistic practice, national identity, and citizenship. She lives in London.

This catalogue has been published on the occasion of the exhibition *Rosemarie Trockel: A Cosmos*, organized by the Museo Nacional Centro de Arte Reina Sofía, Madrid, in collaboration with the New Museum, New York; the Serpentine Gallery, London; and the Kunst- und Ausstellungshalle der Bundesrepublik Deutschland, Bonn.

Museo Nacional Centro de Arte Reina Sofía, Madrid
May 23–September 24, 2012

New Museum, New York
October 24, 2012–January 13, 2013

Serpentine Gallery, London
Spring 2013

Kunst- und Ausstellungshalle der Bundesrepublik Deutschland, Bonn
June 28–September 29, 2013

Rosemarie Trockel: A Cosmos is presented in Madrid in collaboration with

The New York presentation of *Rosemarie Trockel: A Cosmos* is sponsored by

The exhibition is made possible by the generous support of the LUMA Foundation and Ellen and Michael Ringier.

Additional support is provided by Lisa A. Schiff and the Consulate General of the Federal Republic of Germany in New York.

The accompanying exhibition publication is made possible by the Barbara Lee Family Foundation and the J. McSweeney and G. Mills Publications Fund at the New Museum.

Special thanks go to Barbara Gladstone Gallery and Sprüth Magers.

EXHIBITION

Curator
Lynne Cooke

Exhibition Coordinator at the Museo Reina Sofía
Soledad Liaño

Coordination Assistant
Cristina Guerras

Management
Natalia Guaza
Ana Torres

Registrar
Clara Berástegui
Iliana Naranjo
Sara Rivera

Conservator in Charge
Beatriz Alonso

Conservation
Pilar García Fernández
Caterina Paolisso
Mikel Rotaeche

Exhibition Design
María Fraile

Audiovisuals
E-tech Multivisión

Installation
Horche

Shipping
Manterola

Insurance
Poolsegur, correduría de seguros

CATALOGUE

Editor
Lynne Cooke

Museo Nacional Centro de Arte Reina Sofía
Publications Department
Director
María Luisa Blanco

Editorial Coordination
Teresa Ochoa de Zabalegui

Graphic Design
Filiep Tacq

Translation
Jill Buckenham (pp. 9–11)

First published in the United States by The Monacelli Press LLC
All rights reserved

Library of Congress Control Number: 2012941717

The Monacelli Press hardcover edition
ISBN 978-1-58093-346-9

The Monacelli Press softcover edition
ISBN 978-1-58093-360-5

Museo Nacional Centro de Arte Reina Sofía softcover edition
ISBN 978-84-8026-459-4
NIPO 036-12-017-5
General Catalogue of Official Publications:
http://publicacionesoficiales.boe.es
Distribution and retail: http://www.mcu.es/publicaciones

Printed in Italy

Cover: *Spiral Betty*, 2010
Frontispiece: *Go Away Bird*, 2011

CURATOR'S ACKNOWLEDGMENTS

On behalf of all four institutions, I would like to
thank Rosemarie Trockel for her enthusiastic embrace
of my proposal to make an exhibition in the form of a
personal cosmos that would expand on the remarkable
body of work she has created over more than three
decades. We are particularly indebted to Rosemarie
and her assistants, Friederike Schuler and Heide
Häusler, for their dedicated assistance throughout
the conception and realisation of this project.

We are also very grateful for the support of her
gallerists, Monika Sprüth and Philomene Magers,
from Sprüth Magers Berlin London, and Barbara
Gladstone, from Barbara Gladstone Gallery, New
York, for their generous support of the exhibition.
For crucial funding for this publication we owe thanks
to the Goethe Institut, through its director in Madrid,
Margareta Hauschild.

I would also like to thank my colleagues for their
keen interest in the project from its inception, and
their roles in making possible its extended tour:
Massimiliano Gioni, Associate Director and Director
of Exhibitions at the New Museum in New York;
at the Serpentine Gallery, London, its Director,
Julia Peyton-Jones, and Hans Ulrich Obrist, Director,
International Projects, and, with Julia, Co-Director,
Exhibitions & Programmes; and Robert Fleck,
Director of the Kunst- und Ausstellungshalle der
Bundesrepublik Deutschland, Bonn. I am greatly
indebted to the dedicated and painstaking work of
Sole Liaño Gibert, for her assistance in realizing
the exhibition in Madrid, and to her counterparts
at the other venues: Jenny Moore, Associate Curator
at the New Museum, Sophie O'Brien, Senior
Exhibitions Curator at the Serpentine Gallery,
and Susanne Kleine, Exhibition Manager at
the KAH, Bonn.

For their challenging and stimulating essays, I would
like to thank Suzanne Hudson and Anne Wagner.
In addition, Dore Ashton has contributed a
characteristically insightful and revealing text on
Rosemarie Trockel, while Analisa Bacall has been
indispensable as both the author of the artists'
biographies and the project's research assistant.
Filiep Tacq's elegant design and sensitive
collaboration have been essential in the crafting

of this book. I am deeply grateful to Christopher Lyon and Teresa Ochoa de Zabalegui for their perspicacity and precision in the supervision of this manuscript. María Fraile contributed significantly to the installation of the show in the galleries of the Museo Reina Sofía in Madrid.

An ambitious exhibition with a range of diverse loans—many outside the realms of modern and contemporary art—this project relied inevitably on the kind support of colleagues from far-flung institutions. We are deeply grateful for the exceptional loans made so graciously by the following institutions and individuals:

The Art Institute of Chicago
Barbara Gladstone Gallery, New York
The British Museum, Department of Prints
 and Drawings
Creative Growth Art Center, Oakland
Galerie Crone, Berlin
Galerie Yves Gastou, Paris
Jacqueline & Charles Crist
James Castle Collection and Archive LP, Boise, Idaho
Louis-Dreyfus Family Collection
Minneapolis Institute of Arts
Familia Montalvo
Familia Montalvo Cleofé
Lola Montalvo
Musée National d'Art Moderne Centre Georges
 Pompidou, Paris
Museo Nacional de Ciencias Naturales, Madrid
The Museum of Everything, London
The Natural History Museum, London
Real Jardín Botánico, Madrid
Ringier Collection
The Royal Collection, Windsor
Special Collections Research Center, Syracuse
 University Library, New York
Sprüth Magers Berlin London
Staatliche Museen, Berlin, Kupferstichkabinett
University of Aberdeen Museums, Scotland

as well as to those who wish to remain anonymous.

In addition, we are variously indebted to the following individuals for their generous assistance and support:
Imogen Begg
James Brett
Borja Coca

Stephen Coppel
Joaquín Cortés
Tom di Maria
Niels Dietrich
Catherine Drew
Shona Elliott
Darrell Green
Lola Hinojosa
Beatriz Jordana
Raúl Lorenzo
Román Lores
Miranda Lowe
Esteban Manrique
Josiah McElheny
Lola and Jaime Montalvo
Tanya Morrison
Theresa-Mary Morton
Tina Oldknow
María Luz Peñacoba
Gloria Pérez de Rada
Michail Pirgelis
Sean M. Quimby
Javier Sánchez
Kim Sloan